THE ARCHAEOLOGY OF MERSEYSIDE IN 20 DIGS

Liz Stewart and Vanessa Oakden

AMBERLEY

Front cover, top: Excavation underway at Ochre Brook, Tarbock, Knowsley; bottom: costrel found at Church Road, Rainford, St Helens.

Back cover: Excavation underway at Oakes Street, Liverpool.

All images in this book are © National Museums Liverpool unless otherwise stated.

First published 2022

Amberley Publishing
The Hill, Stroud
Gloucestershire, GL5 4EP

www.amberley-books.com

Copyright © Liz Stewart & Vanessa Oakden, 2022

The right of Liz Stewart & Vanessa Oakden to be identified as the Authors
of this work has been asserted in accordance with the
Copyrights, Designs and Patents Act 1988.

British Library Cataloguing in Publication Data.
A catalogue record for this book is available from the British Library.

ISBN 978 1 3981 0950 6 (print)
ISBN 978 1 3981 0951 3 (ebook)

Typesetting by SJmagic DESIGN SERVICES, India.
Printed in Great Britain.

Contents

Introduction

Merseyside has provided a home for people for around 10,500 years. Archaeological evidence is helping us build up a picture of changing lifestyles in the region, and how people have lived their lives in Merseyside utilising the local landscape and resources, from hunting and gathering to industrial extractive industries. Influences of new people moving into Merseyside and innovation of communities and individuals are reflected in the archaeological finds recovered.

The earliest people living in Merseyside were in the mesolithic (middle stone age) period. After the last ice age the landscape of Merseyside became heavily wooded, being colonised by pine, birch and hazel by around 10,000 years ago. The retreat of the ice also meant people were able to occupy the landscape and utilise the woodland as hunting grounds. The population would have been tiny, limited to small groups of hunter-gatherers living solely off wild plants and animals. They were highly mobile, living in small extended family groups and moving around the landscape to find resources as the seasons changed. They hunted and gathered to sustain themselves, establishing relatively short-term camps and moving around the landscape as needed.

The transition from a mobile hunter-gatherer lifestyle in the mesolithic to one that included farming and fixed settlements defines the transition to the neolithic, around 6,000 years ago. Ritual monuments such as burial mounds and other earthworks also begin to be constructed. Connections between our region and other areas are found for the first time in this period, for example with axes being brought from Langdale in Cumbria and links around the Irish Sea evident in the rock art of the Calderstones.

The gradual transition towards a farming lifestyle is completed in the iron age, when farmsteads are enclosed by protective ditches, possibly to corral livestock, and the landscape starts to be divided into pockets of land we might recognise as fields.

The establishment of a fortress at Chester for the Roman 20th Legion might not have altered the lifestyle of everyone in the area immediately, but there is evidence of the links and relationships between local people and the Roman army. Local people are trading with the Romans, producing tiles for the Chester fortress at a settlement in Tarbock. Through trade and barter, coinage comes into use. Meanwhile among the wealthier Britons, the wearing of Roman-style jewellery is evidence of cultural influence.

Place name evidence demonstrates a mix of Anglo-Saxon and Scandinavian settlers in Merseyside in the early medieval period. The expelling of a group of Vikings from Dublin in AD 902 and their being granted land 'near Chester' might explain the density of -by place names in Wirral, a Norse/Norwegian word element denoting a farmstead,

such as Irby, Frankby and Pensby. Raby on the Wirral and Roby in Liverpool are place names meaning 'boundary farm', possibly suggesting an edge to a Viking enclave.

Small hamlets and villages were spread across the landscape of medieval Merseyside. Even the largest places in Merseyside would have had only a few hundred people living in them. At the time of the Domesday Book the hundred – an administrative area – of West Derby encapsulated much of Merseyside, except Wirral and north Sefton. Its parish church was probably on the site of St Mary's Church, Walton-on-the-Hill. Benedictine monks from Birkenhead Priory ran ferries across the Mersey from 1125 to the village of Liverpul, named after the muddy pool of a tidal inlet. This place name is first mentioned in 1190, having been overlooked in the Domesday survey as a small outlying berewick of West Derby. In 1207 King John recognised the potential of the pool as a safe port of embarkation for Ireland and founded the borough of Liverpool. King John's letters patent created opportunities for economic expansion, but in 1229 Henry III abandoned the embryonic town by granting it to the earls of Chester. The local gentry jostled to gain power, and by the fifteenth century the rival Stanley and Molyneux families dominated the town. Population and economic growth were slow, and by the Tudor period Liverpool still had just the seven streets that had originated in the thirteenth century. Disaster struck in 1557–59 when a plague killed a third of Liverpool's population, which had probably hovered at around 1,000 people.

Dozens of moated manor house sites have been traced in Merseyside. People living in small agricultural villages were overseen by these manor houses and their produce – including wheat, barley, oats, and vegetables – taxed by the manor. Sheep farming was also common in the region, and wool cloth was part of the early export trade from Liverpool. Small industries in the surrounding areas started to benefit as the port of Liverpool developed in the 1500s and 1600s. Liverpool burgesses had begun to develop trading contacts around the Irish Sea, exchanging farm produce from Lancashire and Yorkshire for iron from Furness and cattle and hides from Ireland. However, until the seventeenth century Chester had been the primary port of the North West. Gradually the impact of the silting of the River Dee, combined with renewed entrepreneurial activity in Liverpool, shifted the emphasis to the Mersey. The improving commercial importance of Liverpool was underlined during the English Civil War, when the town changed hands three times between Royalists and Parliamentarians.

It was in the later seventeenth century that Liverpool's growth really accelerated, thriving because of its west-facing location, which provided an ideal starting point for maritime expansion. In 1648 the first cargoes imported from America were recorded and in the 1660s a number of businessmen and entrepreneurs relocated to Liverpool, driven from London by the trials of the plague and the Great Fire, keen to exploit the town's burgeoning trade. Liverpool's involvement in the abhorrent trade in enslaved African people, beginning in 1696, created prosperity for some at the expense of many thousands of people. Enslaved people were shipped from Africa to the Americas and slave-produced goods brought back to Liverpool, including sugar, tobacco and cotton. This spurred the development of Liverpool's dock system as well as upgraded roads and early canal and rail links. Liverpool was on its way to becoming the 'second port of the Empire'.

The merchant class funded their own luxurious lifestyles and mansions, and also invested in cultural institutions around Merseyside. Juxtaposed against such tremendous wealth and splendour was horrendous poverty. The city's population exploded in the nineteenth century. Inward migration of a diverse population of hopeful transatlantic

migrants, seafarers, and people seeking opportunity in the city made Liverpool one of the most multicultural cities in Victorian Britain. But such rapid population growth was not without cost. With its crowded, unsanitary courts and slum cellar dwellings, Liverpool became known as 'the Blackspot on the Mersey'. In its response to these problems Liverpool also proved to be a pioneer in the field of public health. In 1846 the corporation appointed Britain's first Medical Officer of Health and in 1869 St Martin's Cottages opened as the first social housing in the country.

Merseyside as we know it today was created following the Local Government Act of 1972, prior to which it lay within the historic counties of Lancashire and Cheshire. Through archaeology we can take a look at the stories of communities within our cities, towns and villages and the landscape within which they lived prior to modern administrative borders. Archaeology captures fragments of the vast range of human experience of life in Merseyside. By revisiting twenty excavations that have taken place over the last sixty years we explore the evidence for the people who came before us in an archaeology of Merseyside in twenty digs.

Drawing from the collection of the Museum of Liverpool, twenty digs have been selected that enable us to write a narrative for the different periods of Merseyside's history. Often a single site will reveal settlement from several periods of history.

The Museum of Liverpool (part of National Museums Liverpool) is the repository for finds and archives from archaeological excavations in Merseyside. It holds over 100,000 objects from over 150 excavations and chance discoveries.

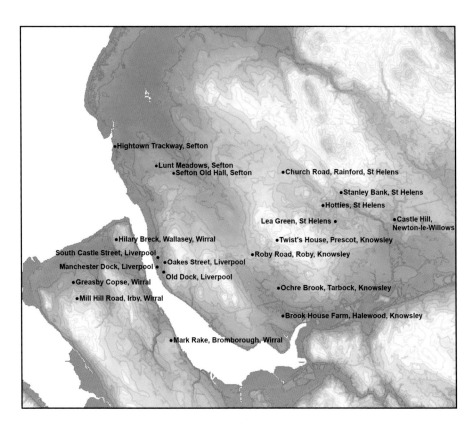

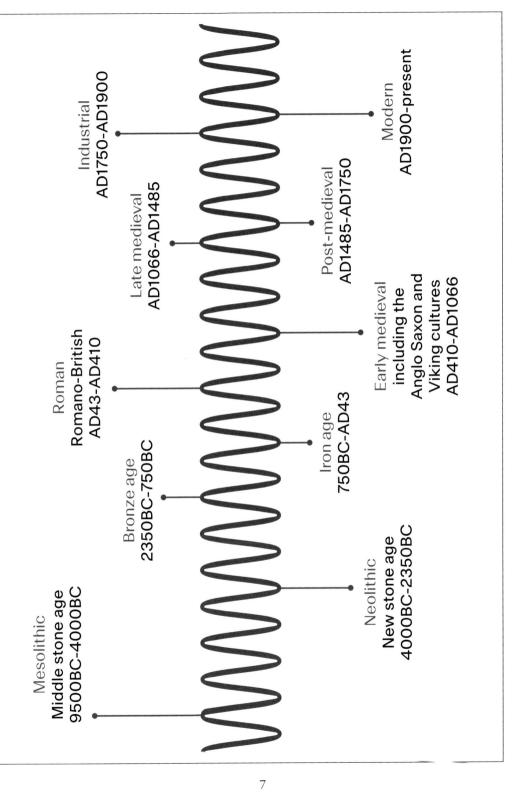

Mesolithic
Middle stone age
9500BC-4000BC

Neolithic
New stone age
4000BC-2350BC

Bronze age
2350BC-750BC

Iron age
750BC-AD43

Roman
Romano-British
AD43-AD410

Early medieval
including the
Anglo Saxon and
Viking cultures
AD410-AD1066

Late medieval
AD1066-AD1485

Post-medieval
AD1485-AD1750

Industrial
AD1750-AD1900

Modern
AD1900-present

Prehistoric Merseyside

Excavated sites and chance prehistoric finds combine to help us understand the lives of the earliest people living in this region.

The first people living here, after the end of the last ice age, hunted and gathered to sustain themselves, establishing relatively short-term camps and moving around the landscape as needed. Few material traces survive but those that do include scatters of small stone tools, palaeobotanical samples (seeds and plant material extracted from soil samples), and marks of postholes and remains of structures in soils.

Chance finds of neolithic and bronze age axe heads are testament to efforts to adapt the landscape by clearing forests in this period. Environmental and cultural change is seen too, with the creation of monumental communal burial places and the introduction of farming and pottery.

The introduction of metalworking in the form of bronze tools marks the start of the bronze age. Metalworking continued to develop, and around 650 BC ironworking began – the iron age. This period provides the first good evidence for the introduction of large, fixed settlements in the landscape in the North West.

Dig 1: Greasby Copse, Wirral

Period(s) : Mesolithic
Grid Reference : SJ 257 861
Lead Excavator(s) : Ron Cowell, National Museums Liverpool
Year(s) **Excavated** : 1987–90
Accession Number : 1998.124

As people lived in temporary camps, the archaeological evidence for Merseyside's mesolithic hunter-gatherers' lives is scarce, but a few very special sites have taught us a great deal about life in this period. Numerous mesolithic sites have now been identified in Merseyside through a combination of field walking and environmental evidence, and a handful have been excavated. The Greasby Copse site was discovered through the field walking programme in 1984. Collecting chance finds from the surface of ploughed fields is often an effective way to identify areas of human activity, and may indicate buried sites. The Greasby Copse site was chosen for excavation between 1987 and 1990, because the types of lithics – stone tools – found were different from other hunter-gatherer surface sites known in Merseyside.

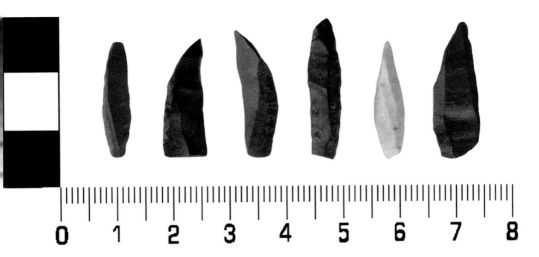

Stone tools excavated at Greasby.

The excavation at Greasby Copse revealed several earth-cut features, often resulting from the fall of trees, in the same area as the stone tools in the north of the site, and an intensely pebbled area in the south of the site. Some special finds from the tree root hollows are hazelnut shells, which were radiocarbon dated to over 10,000 years old – Merseyside's oldest meal! The changing landscape and environment have left a record in the pollen and seeds found in ancient, buried soils and peats in Merseyside. The area was gradually colonised by pine, birch, oak and hazel woodland, providing food and raw materials for hunter-gatherers.

> Greasby was my first big local excavation and for nearly 30 years has been special. The strong sense of place and deep time there meant it was more than just a scientific process of recovering evidence. When conditions were right you could almost sense the lost way of life and ancient beliefs that all the evidence was witness to.
>
> Ron Cowell, lead archaeologist

Over 10,400 individual fragments of worked stone, including tools and waste chips of chert and flint were found at Greasby. Chert and flint would have been imported to the sandstone-rich area of Wirral. After the end of the last ice age, between 12,000 and 11,000 years ago, Britain was becoming an island, and its coastline started to take shape, but remained considerably different from the present one, with land links across the areas of the Mersey and the Dee. This provided access to North Wales, a source of chert to enable hunter-gatherers in Merseyside to make the tools essential to survival. Very little is known about potential contact between hunter-gatherer groups, but the presence of stone imported from across the River Dee suggests that the people who had temporary camps such as Greasby had strong connections with other groups over some distance, and may even have spent part of their time in North Wales.

> Ron loved digging in the height of winter with its ethereal lighting especially at dusk, but days were short and the digging cold. I remember breaking the ice on the water

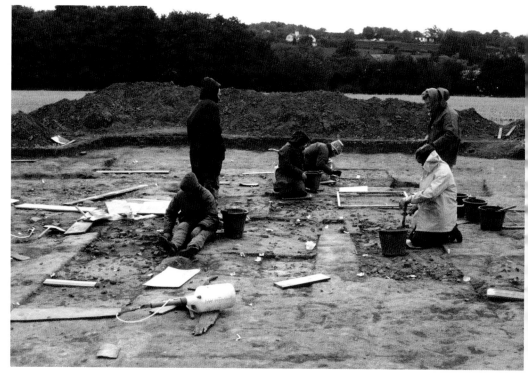

Excavation underway at Greasby.

trough to sieve the soil excavated so we could capture every flake of chipped flint and stone and hazelnuts from the ancient camp fires.

Jeff Speakman, archaeologist

The Greasby Copse site is quite distinctive from other local early prehistoric sites. It has produced far more stone tools than most sites, and the density of features implies there were fixed structures here, something not seen at other mesolithic sites in the region, with the exception of Lunt Meadows, Sefton (see page 12). This suggests that the site was used over a long period, revisited repeatedly.

It helped form the way that I and possibly several others who dug there have since looked at the world. The close connection to the site and its evidence left us empathising with the respect for nature, the landscape and the balance with the seasons that must have existed in these people through their hunter-gatherer way of life.

Ron Cowell, lead archaeologist

A group of pits at Greasby Copse, especially the one or possibly two that were lined with stones, suggests the possibility of storage of foodstuffs. In hunter-gatherer societies this could enable groups to stay in one place without having to move around the

Concentration of early mesolithic pits at Greasby.

landscape so frequently to follow food resources. Alternatively, the pits could have been hearths (although no evidence of burning within them was recovered), rubbish disposal points, or special or ritual locations. One pit contained a seemingly careful deposition of three stone blades and two small stone flakes at the base under a group of pebbles. The pits and hollows show evidence of being reused a number of times, supporting the theory that a significant amount of time was spent at Greasby through returning visits over multiple seasons while the pits were in use.

No direct evidence of buildings was discovered – settings for wooden stake or post wall supports, or floors were absent. Given the relatively dense cluster of pits and finds, it is likely that occupation would have been substantial enough to warrant some form of structures on the site. These delicate features may have been damaged by modern agricultural disturbance. Alternatively, they may have been in another area outside the zone excavated.

The huge number of flint and chert tools found at Greasby were clearly made on this site and were used for the hunting of animals across a large area of land. In the later mesolithic period changes in temperature would have raised sea levels and impacted the type of woodland. Changes in the coastline and fluctuating sea levels would have brought the coast closer to Greasby, providing new resources, which could have been exploited.

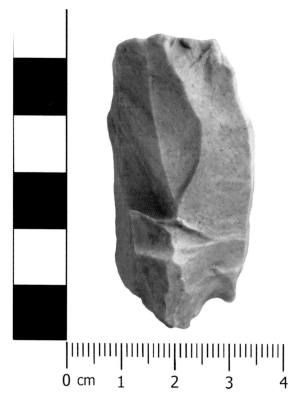

Flint core excavated at Greasby.
(1998.123.1879)

0 cm 1 2 3 4

FIND OUT MORE

Prehistoric Merseyside activity book:
https://images.liverpoolmuseums.org.uk/2021-10/Prehistoric-Merseyside-2021-.pdf

A number of finds from Greasby are on display in the Timeline in the Museum of Liverpool

Dig 2: Lunt Meadows, Sefton

Period(s) : Mesolithic
Grid Reference : SD 352 024
Lead Excavator(s) : Ron Cowell, National Museums Liverpool
Year(s) Excavated : 2012 – present
Accession Number : MOL.2014.122

Locating the remains of the houses and settlements where hunter-gatherers lived is an archaeological challenge. Archaeological monitoring of an Environment Agency flood

alleviation scheme in the River Alt valley, Sefton, led to the discovery of just that, a site where hunter-gatherers lived, building houses on a sandy area next to the wetlands of the valley floodplain. This area would have been appealing to hunter-gatherers who would have benefitted from a range of natural resources from the coast, river, wetland and woodland landscapes.

This is the site of a hunter-gatherer settlement within a woodland environment including hazel, pine and oak trees. Using the local resources, as well as imported materials, people living here carved out a life for themselves.

At Lunt, the preservation of the deeply buried hunter-gatherer camp nestled in the wild landscape allows the two elements to feed off each other in a way that is unique. It adds an extra dimension to help understand and better experience both. The landscape of the modern nature reserve has echoes of a past that is in front of your eyes.

Ron Cowell, lead archaeologist

During the main phase of occupation, around 9,300 to 9,000 years ago, structures were built in two adjacent areas. The buildings can be identified from stake holes and curved gullies, which enclose areas of pitting within the living spaces. The buildings were relatively lightweight and would have needed repair and rebuilding to be used

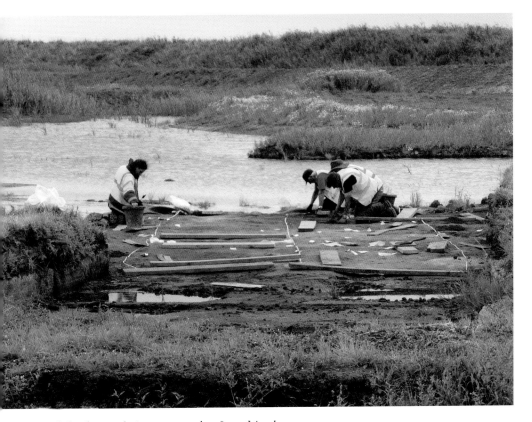

Mesolithic houses being excavated at Lunt Meadows.

over a period of time. Within each area of the site, the archaeology indicates that the structures overlapped when rebuilds took place. This shows intermittent long-term use with people returning to the location over generations. A linear sand bank links the two occupation areas, and low sand banks mark a potential entrance to the settlement. There were remains of several trees on the site, which were of roughly contemporary age, interspersed with the remnants of the houses. People had built their homes within the woodland in small gaps between the trees. One tree was totally burnt down around 5800 BC, and special stone and flint deposits placed under the fallen trunk. This must represent a highly significant event for the people there – whether the tree fire was natural or intentionally set alight by humans.

One area of pitting and formal pebble deposition provides evidence for repeated acts that seem to have symbolic significance. Distinct stone groups made up of sequences of overlapping pebbles were placed over earlier pits. One group formed an arc arranged around a large (1.4 kg) pebble of granite. The surface of the stone is rich in mica crystals and sparkles when hit by light. This characteristic may have been special or appealing to the people who placed the stone there.

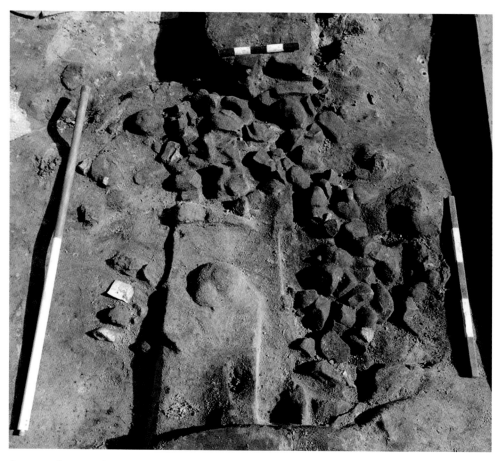

Groups of stones placed in a pit in an intentional arrangement at Lunt Meadows.

Detail of the large iron-stained, mica-rich granite pebble. (MOL.2014.122.1475)

Lunt Meadows brought 30 years-worth of work on local mesolithic sites full circle for me. It was invisible, buried deeply beneath layers of flooding so to find it was pretty special. I had in fact predicted where it might be to the contractors on the site and I think they thought it was almost magic when it turned up, but really it just needed bits of accumulated knowledge putting together.

Ron Cowell, lead archaeologist

Around 5,500 struck pieces of chert and flint are the remains of the tools used by the hunter-gatherers living in the area. As at Greasby (see page 8) these do not reflect the locally available stone and demonstrate some level of contact, via river, sea and land to areas where valuable resources could be acquired, the closest sources being North Wales and east Lancashire. Microliths have been found in the northern occupation area. Microliths, tiny pieces of chert or flint, would have been mounted in groups to create tools such as a fishing spear. Radiocarbon dates for this area date material to around 9,000 years ago, although these dates are not yet directly associated with the artefacts.

The natural environment of the River Alt valley and resources it provided to the hunter-gatherer people would have attracted them to this area, but were also the final factor in their leaving. After around 5500 BC the site was flooded by fresh water, allowing a reed swamp environment to develop, and then inundated by the sea to create a salt marsh. The rise in sea level and flooding of many areas, including this site, is associated with an increase in alder trees across the region. All the discoveries at Lunt Meadows are known to date to before that period, the sealed remnants of life before the water rose.

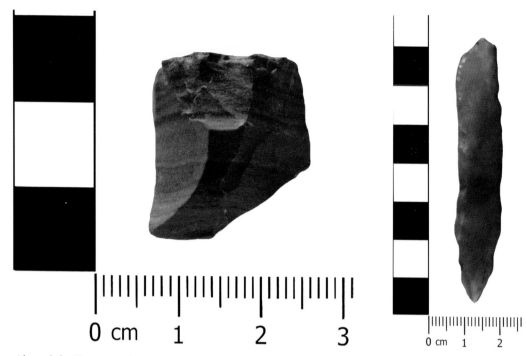

Above left: Chert core found at Lunt Meadows. (MOL.2014.122.2367)

Above right: Flint implement found at Lunt Meadows. (MOL.2014.122.4153)

This site is part of a National Lottery Heritage Fund supported project to interpret the fascinating human past in the area alongside the natural environment of the wildlife reserve.

FIND OUT MORE

- Lunt Meadows AR Explorer App – available on GooglePlay and Apple app store
- Visit Lunt Meadows Nature Reserve, managed by the Wildlife Trust, L29 8YA
- Lunt Meadows display in the History Detectives Gallery in the Museum of Liverpool

Dig 3: Hightown Trackway, Sefton

Period(s) : Neolithic
Grid Reference : SD 294 024
Lead Excavator(s) : Ron Cowell, National Museums Liverpool
Year(s) Excavated : 1996
Accession Number : MOL.2009.38

Formby Point has become a centre of archaeological attention because of an amazing array of prehistoric bronze age animal and human footprints recorded in the area by Gordon Roberts. In 1996 a small lichen-covered mound was discovered in the area, and an evaluation was carried out to assess its significance. It appeared it may have been the remnants of a wooden trackway. Soon a fuller excavation took place.

The mound represented a section of laid, interwoven branches above the beach level, which then dropped down onto the bluey-grey clay that forms the beach. The wood was traced across the beach for around 60 metres running north-east south-west. It was well preserved in around a 4-metre length, much of which was excavated in detail.

> It was really nice soft blue clay – lovely to dig through. You could feel when you reached the wood with your fingers.
>
> Ron Cowell, lead archaeologist

Because so much of the structure had already disappeared, and the imminent high autumn tides and potential storms might remove much of the surviving wood, the excavation was undertaken rapidly. It is possible that more of it survives under the sand dunes where brick has been placed to prevent erosion. The excavation was able to evaluate the construction and preservation of the structure located on the beach. This was the first modern excavation of a potential trackway in the North West, and usual archaeological excavation and recording techniques needed to be adapted to capture information about it.

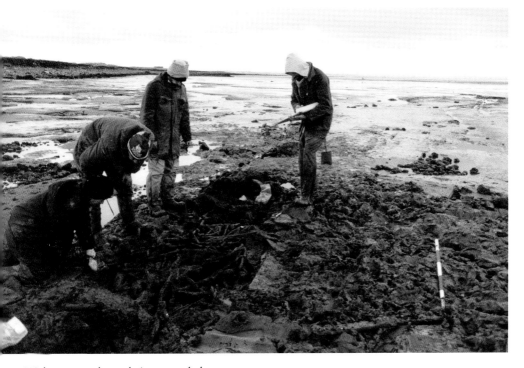

Hightown trackway being recorded.

As the overlying mud was removed it soon became apparent that the soft nature of the wood meant that one tide could easily break the outer pieces and remove them from their original context, so the trackway was protected from the sea each night with plastic sheeting and mud. Excavation was mainly undertaken with plastic spatulas and fingers, but even this did not prevent damage to the surfaces of the incredibly delicate soft wood in scraping away the clay. Most pieces of wood used in building the structure retained their bark.

Around a third of the wood was retained for analysis of size, cutting, radiocarbon dating and species counts. The construction of the trackway included wood laid partly interwoven and partly relatively haphazardly in three layers. It had potentially been disrupted by water action over the millennia. The tides and changes in natural conditions and climate can damage archaeology, but also reveal it. At Meols in north Wirral, beach finds washed out in coastal erosion in the late nineteenth century tell of a settlement and trading centre from the Roman to post-medieval periods.

It is the haphazard way in which some of the wood has been laid that has led to debate about whether the structure found at Hightown was a trackway or a more natural feature such as a dam created by prehistoric beavers. Within the structure there is both evidence of human tooling on wood and gnawing of animals. Modern beavers are not thought to be very saltwater tolerant, but examples have been found in Canada of modern beaver dams across creeks in salt marsh areas.

Radiocarbon dating places the trackway at around 3500–2500 BC, in the neolithic period. Neolithic trackways are uncommon in Britain, the earliest being the Sweet Track in Somerset. Other examples have been found in Ireland, such as the well-preserved

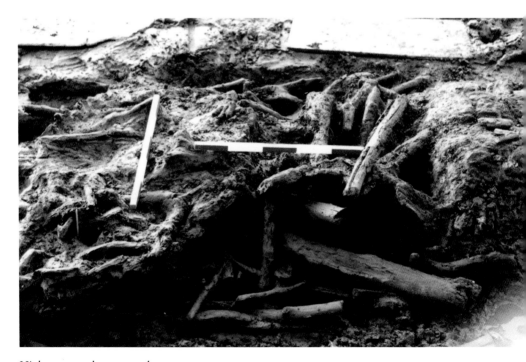

Hightown trackway wood.

trackways at Corlea and Edercloon in County Longford. Hightown is the first potential trackway excavated in the North West apart from the Kates Pad trackway excavated in 1850 in a peat bog in Wyre, Lancashire. That was of very different structure, with split oaks set across sleepers, which has been dated to the later bronze age.

> The small area available for excavation and the overall effect is a bit ambiguous as it is unlike any other known trackway. We don't have enough secure evidence to totally discount it as having been created by beavers. But even if so, I would still find it a totally fascinating element of the local late neolithic coastal landscape to go alongside all the evidence for human activity we have there.
>
> Ron Cowell, lead archaeologist

The intertidal area around Crosby and Formby has also produced amazing remnants of animal and human footprints. Over 150 human trails, and large areas of deer, aurochs and occasional bird footprints, occur in muds and silts representing former intertidal creeks. Dating of these features is limited but their location and levels in the silts suggest that they are pre-1500 BC. The footprints have been preserved because they were in an area of fairly frequent tidal inundation; the trackway lay on a tidal lagoon and may have been damaged by the sea. The footprints might represent humans hunting the

Prehistoric footprints on the beach at Crosby.

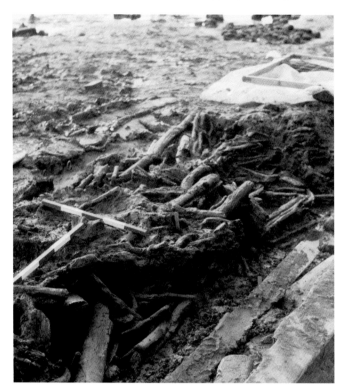

Hightown trackway during excavation.

animals on mudflats. The trackway is potentially a constructed route across the salt marsh where the sea entering the tidal estuary occasionally reached. It is possible these two amazing archaeological sites were contemporary – people using adjacent areas in slightly different ways.

FIND OUT MORE

🖥 Prehistoric Merseyside activity book: https://images.liverpoolmuseums.org.uk/2021-10/Prehistoric-Merseyside-2021-.pdf

🖥 Museum of London CITIZAN blog: www.citizan.org.uk/blog/2016/Jan/28/prehistoric-footprints-first-lifeboat-station/

Dig 4: Brook House Farm, Halewood, Knowsley

Period(s) : Iron age
Grid Reference : SJ 473 850
Lead Excavator(s) : Ron Cowell, National Museums Liverpool
Year(s) Excavated : 1992–93
Accession Number : 1997.109

Before work started on the A5300 link road (between the M57 at Prescot and the A562 Speke to Widnes road) archaeologists were on the scene, first field walking and then undertaking a programme of archaeological excavation to rescue the archaeological information before it was destroyed by the development. The A5300 is approximately 4.5 km long and encountered four main sites, of which Brook House Farm is one.

Aerial photographs taken in 1991 gave the hint of a double-ditched enclosure, rectangular with rounded corners, which looked as if it might date to the Romano-British period. The initial archaeological evaluation in summer 1993 involved excavation of small areas. This confirmed that the area within the ditches was rich in archaeological evidence. Further excavations in autumn 1993 helped date the enclosure to the iron age and enhanced understanding of some of its functions.

The main trench investigated the area from the central part of the enclosure eastwards, to include the internal and external enclosure ditches. The external enclosure ditch was 2.5 metres wide at the surface, flat-bottomed and 0.9 metres deep. The inner ditch, some 35 metres away, was a deeper U-shaped cut around 3.5 metres and around 8.5 metres wide. These ditches enclosed an oval area of around 1.5 hectares. A smaller third ditch, terminating on the west side around 4 metres from the inner enclosure ditch, was found during excavation, running east to west. This was probably part of a field boundary.

Postholes marking out parts of two structures were found (the rest outside the excavation area), and iron age very coarse pottery (VCP). Slightly later structures were discovered, with gullies and postholes surviving. This suggested the site was occupied for several generations through the iron age. These buildings have been interpreted as mainly for grain storage, with one possible house. While the structures were identified

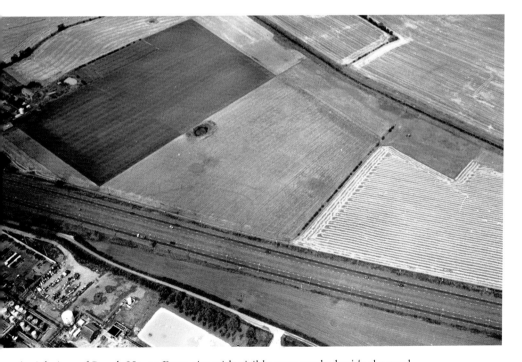

Aerial view of Brook House Farm site with visible crop marks beside the road.

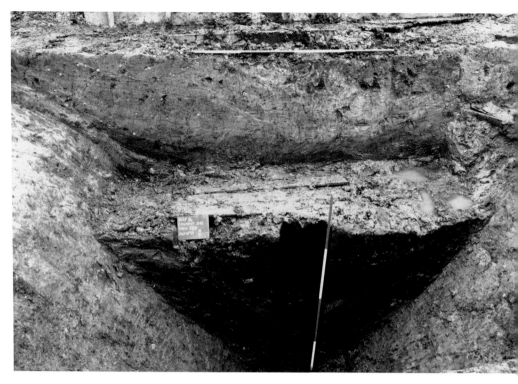

Iron age ditch under excavation at Brook House Farm.

by postholes, fragments of daub were also found, giving more clues about the way they we built. Boundary gullies marking out different areas were found, and pits, which could ha been used for storage or rubbish disposal. VCP, burnt bone and a whetstone in the gully shc it being filled with washed silt and waste in the mid- to late iron age.

> The wealth of archaeology along the A5300 caused us to realise for the first time that this part of North West England was not the wild, wet, sparsely settled land that you would imagine from its lack of coverage in text books. You might have to look a bit harder than in other parts of the country, but it was there.
>
> Ron Cowell, lead archaeologist

This fascinating iron age site produced large quantities of VCP pottery, but very little otl pottery. VCP is associated with salt production and transportation, which would have be important for the preservation of food. The Middlewich/Nantwich areas of Cheshire were at t heart of salt production for the region and an extensive trade network grew up around the Salt would have been important in preserving food, and the trade in it may have been lucrative the iron age and Romano-British periods. It is possible that the earthen bank and ditches arou the site were a statement of authority, status and control as well as offering defensive protectic

The waterlogged soils at the base of the inner enclosure ditch were packed full of natu wood and one unique find: a wooden block with chamfered edges on one face and a cent hole. This object is unique in the country and its function is not known, but it may be a stat

Daub excavated at Brook House Farm. (1997.109.127)

Very coarse pottery rim excavated at Brook House Farm. (1997.109.19)

base or even a column top used as decoration. The wooden block has been radiocarbon dated to the late bronze age of 1000–800 BC. The object may have been in use for a long time at another location or may have been in use at an earlier, unidentified phase of occupation at Brook House Farm.

> The inner ditch was deep and wide, filled with wonderful wooden objects, but two of the layers were amazing to uncover; individual leaves falling out of a wet layer that was reminiscent of an autumn leaf fall but having been buried for thousands of years.
>
> Jeff Speakman, archaeologist

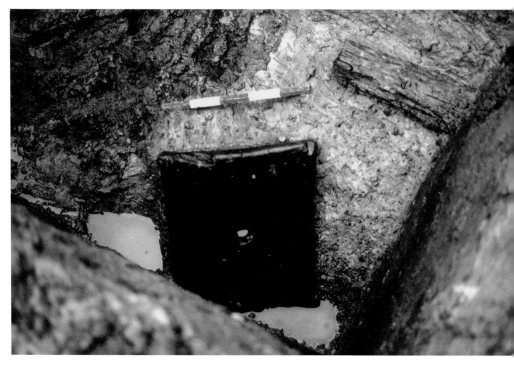

Wooden plinth during excavation at Brook House Farm. (1997.109.34.2811)

It's difficult to understand all the possible functions of the site but grain storage and links to the salt trading network seem clear. Three pits were excavated – possibly waste pits. These contained a small number of pieces of pottery and fragments of iron-rich slag. Small quantities of charcoal and slag were found in soils in postholes, pressed around a post to support it. This suggests some metalworking took place on the site. Among the bone found in the inner ditch fills are butchered bones, linking the site with pastoral farming taking place in and around the ditched enclosure. It has been suggested that the wide gap between the two ditches may have created a corral area for animals.

While hill forts are found across Cheshire and North Wales, farmstead sites in Merseyside and Lancashire, like Brook House Farm, are the primary form of settlement in the lowland areas. In this period the population would have been increasing and villages expanding. To feed this growing population woodland was being cleared and farming intensified.

FIND OUT MORE

📖 *Prehistoric, Romano-British and Medieval Settlement in Lowland North West England* by R. A Philpott and R. W. Cowell

💻 Court Farm, Halewood www.liverpoolmuseums.org.uk/court-farm-halewood

Romano-British Merseyside

Archaeological evidence shows us the huge regional variations in life during the Roman administration of Britain. In the North West the presence of the Roman army was primarily centred at Chester, Manchester, and along the frontier of Hadrian's Wall. The Roman army was largely drawn from other provinces in the empire, while the native, Romano-British inhabitants continued their predominately rural lifestyle, gradually adopting elements of Roman culture.

Evidence shows people continuing to live in roundhouses and on farmsteads as they did during the iron age. However, evidence from the material culture, including the Wirral style of Roman brooch and the presence of Roman coins and pottery, reveals the Roman influence.

Romano-British sites in Merseyside have been excavated less frequently than sites dating to later periods. Many sites where Roman activity takes place, including those discussed here, are multiperiod sites – areas where activity continues before or after the Roman period, AD 43–410. Chance finds collected and recorded by local antiquarians at Meols, Wirral, and more recently through the work of the Portable Antiquities Scheme, underline how much activity there was during the Romano-British period in Merseyside, often in the form of trade and military networks.

The local tribes in this region responded very differently to Roman authority. The Cornovii – a tribe with their capital at Wroxeter, and extending north to the Wirral – submitted to Roman rule. The Brigantes – who controlled much of northern England including areas of Lancashire, Yorkshire and Northumberland – signed a treaty with the Romans. However, not all tribespeople agreed, and some of them rebelled and fought against Roman control. The Ordovices – based in North Wales – were hostile to the Romans. Two fantastic sites, Irby and Ochre Brook, both give us an insight into Romano-British Merseyside. Each is a multiperiod site with its own distinct story, providing us with evidence that important or resource-rich locations were used and reused throughout multiple periods. It is through archaeology that these stories can be unpicked and retold.

Dig 5: Mill Hill Road, Irby, Wirral

Period(s) : Bronze age to medieval
Grid Reference : SJ 252 852
Lead Excavator(s) : Rob Philpott, National Museums Liverpool
Year(s) Excavated : 1987–96
Accession Number : 1995.105

The chance discovery of a Roman pot when 'digging for victory' in an Irby garden in the 1940s eventually led to the excavation of a long-buried Romano-British farmstead. The pot was kept in a powdered milk tin for forty years before it was brought to Liverpool Museum (now World Museum). In 1987 foundation works for a kitchen extension revealed more Roman pottery and the family invited archaeologists to investigate. Over the next decade more than forty trenches were dug across several neighbouring gardens.

> The first decent-sized trench located the ditch, and lying in the bottom was a broken sandstone quern, for grinding cereals – a classic Roman find. From then we dug dozens of trenches over several years, with the great enthusiasm and support of the landowners. It became the done thing to have archaeologists at the bottom of the garden.
>
> Rob Philpott, lead archaeologist

The excavations revealed that the site had been repeatedly reused from the mid-bronze age to the medieval period. The most intensive activity was during the Romano-British era when the farm was occupied for well over 300 years, from the first to the fourth centuries AD.

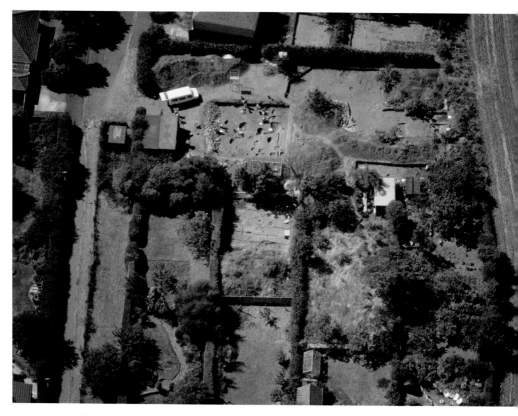

Aerial view of the excavation at Mill Hill Road, Irby.

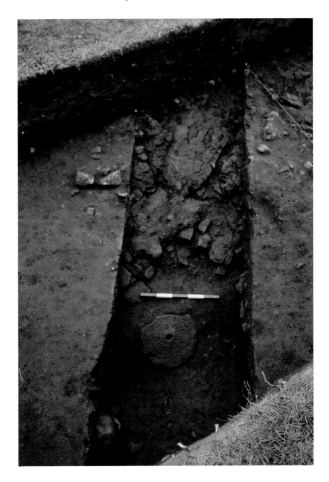

Quern in ditch during excavation at Mill Hill Road, Irby. (1995.105.8373)

One of the nice things about the site was that it had probably never been ploughed since it was abandoned around 1200 AD so the stratigraphy was pretty much intact where it survived; it was fortunate that the houses built on the site in the 1930s had really big gardens.

Mark Adams, site supervisor

The local landscape provides areas of well-drained soil, such as the raised land of Mill Hill, which are suitable for crops, along with wetter soil over boulder clay, which suits growing grass for animals. The people first settling here would have chosen this place for those qualities, among others. Initially, two large roundhouses were built in the bronze age. These were constructed with timber posts, walls of wattle and daub and thatched roofs. This type of house continued in use for millennia and it's clear from finds that this site was in use through the iron age and Romano-British periods. Generation after generation rebuilt their homes here on overlapping or adjacent spots. As well as the postholes marking out the locations of roundhouses, this site produced evidence of their construction: fragments of clay daub, some showing the impressions of the wattle in the walls.

I remember the time when mapping back at the office revealed a large roundhouse which had been seen in three trenches, open at different times, but recorded as different features on each occasion. It was only to be seen as a whole as the plans were brought together for the first time.

<div align="right">Jeff Speakman, archaeologist</div>

In the third century BC a spindle whorl carved from soapstone was in use at Irby, acting as a weight on a spindle when spinning wool into yarn. This unique object is skilfully carved with a fashionable style of curved line La Tène decoration. While we don't know where this artefact was made, soapstone is uncommon in Britain, the closest source being in Anglesey. This small object tells us about the skill of the iron age craftsperson and the trading connections that brought the material or finished object to Irby.

The arrival of the Roman army to establish a fortress at Chester in AD 79 marked a new era in the region's history. Farmstead sites like Irby, though, demonstrate that for many people life continued very much as before. Gradually there were cultural changes, and by the fourth century the buildings at Irby looked more 'Roman' in style, rectangular in shape with stone foundations.

The finds help paint a picture of life in the Romano-British period at Irby, reflecting the influence of the Roman Empire and local traditions. A variety of pottery was found, some locally made, and much brought from other parts of England and from Europe, indicating trade links. The occupants of the farm were largely self-sufficient, growing their own food, making or repairing iron tools, and spinning wool for clothing. Luxury

Steatite spindle whorl under excavation at Mill Hill Road, Irby. (MOL LI 20/2009)

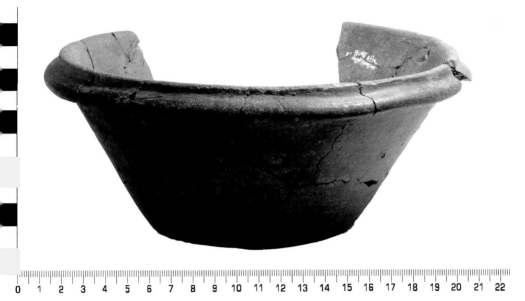

Black burnished ware bowl found at Mill Hill Road, Irby. This type of pottery was imported from Dorset. (1995.105.8078)

imported items like glass beads suggest there was surplus in food produced by the people living at Irby, which could be traded for other goods. Very few coins were found, so bartering for goods was likely to have been common.

Irby's long habitation sheds light on many periods, and the excavation produced rare evidence of a Viking farmstead. The place name 'Irby' is Old Norwegian for 'farmstead of the Irishmen'. These new settlers used the site of the Romano-British farm, perhaps

arge glass bead excavated at Mill ill Road, Irby. (1995.105.6603)

0 cm 1 2 3 4 5 6

Anglo-Norman spike lamp
excavated at Mill Hill Road,
Irby. (1995.105.4888)

because the banks and ditches were still visible. Viking longhouses built here had slightly curved walls, a variation on the traditional rectangular layout.

> Julie Edwards from the Grosvenor Museum put me straight about a find which I thought was a Roman lamp – it was actually a 9th or 10th century AD 'spike lamp' – a really important discovery. At Irby we had an extremely rare Viking-age settlement, built on the remains of the Romano-British farm. This made sense of a series of buildings that didn't fit typical Roman forms – but matched Viking houses in the Atlantic world.
>
> Rob Philpott, lead archaeologist

The repeated use of the same spot for settlement over the millennia is intriguing. The location may have been remembered and passed down by word of mouth or it could simply be that local resources and farming opportunities there made it a desirable place to live.

FIND OUT MORE

📖 *Irby, Wirral: Excavations on a Late Prehistoric, Romano-British and Medieval Site, 1987–96*, by R. A. Philpott and M. Adams

☞ Finds from Irby are on display in the History Detectives gallery at the Museum of Liverpool

💻 Museum of Liverpool regional archaeology collection online: www.liverpoolmuseums.org.uk/collections/archaeology

Dig 6: Ochre Brook, Tarbock, Knowsley

Period(s) : Mesolithic, Romano-British, medieval
Grid Reference : SJ 463 890
Lead Excavator(s) : Ron Cowell, National Museums Liverpool
Year(s) Excavated : 1993
Accession Number : 1997.78

The A5300 corridor was rich in archaeology, as we have seen at Brook House Farm (see page **20**). Fieldwalking along the length of the proposed road attracted attention to an area near the small stream of Ochre Brook, where a scatter of prehistoric stone tools and flakes was discovered. More prehistoric tools were discovered during the excavation, but the key, previously unknown, phase of interest was the Romano-British occupation of the site.

> It's fascinating that Ochre Brook isn't just one site: there's the mesolithic and its landscape context; and then the Roman – a completely different use of the place.
>
> Ron Cowell, lead archaeologist

The Romano-British farmstead at Ochre Brook was surrounded by a large ditch. Two long, interrupted stretches of ditch forming the sides to the north and to the west show it was rectangular in plan, with a 3.5-metre-wide entrance gap to the west. No trace of the eastern side of the enclosure was recovered, but later ploughing in the downslope area of the site may have destroyed a shallow ditch.

The earliest evidence of people living on the site is a series of rubbish pits containing charcoal fragments, roofing tile and black burnished ware pottery. These finds indicate that this rubbish pit was filled by around AD 120.

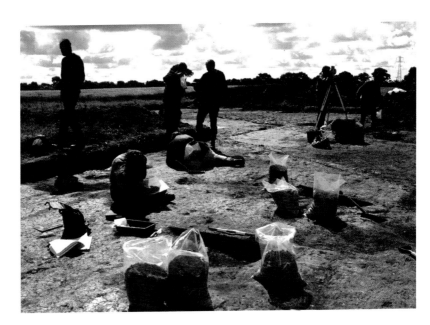

Excavation
underway at
Ochre Brook,
Tarbock.

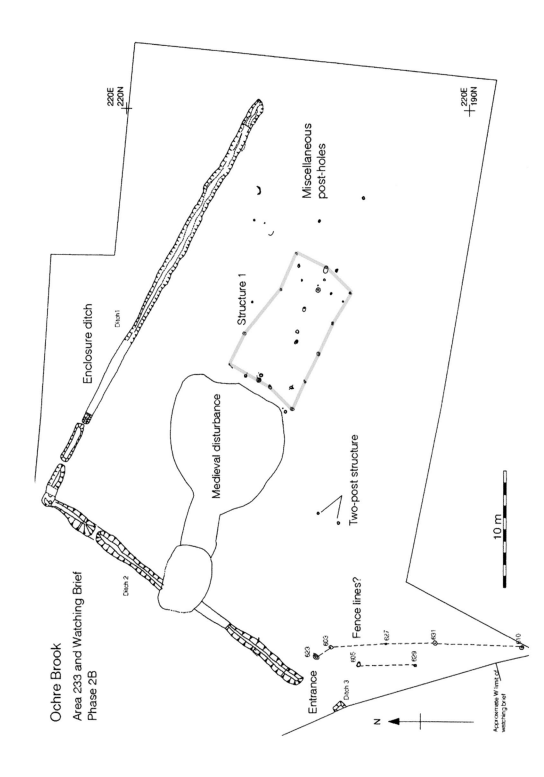

Ochre Brook

Area 233 and Watching Brief
Phase 2B

Enclosure ditch

Ditch 1

Medieval disturbance

Ditch 2

Structure 1

Miscellaneous
post-holes

Two-post structure

Fence lines?

623

605

627

625

629

631

610

Entrance

Ditch 3

220E
220N

220E
190N

N

Approximate W limit of
watching brief

10 m

Coming to the North West lots of the archaeologists were frustrated there was nothing on the site. Only local archaeologists recognised a layer of clay wasn't natural. As soon as that was stripped you could immediately see a pit packed with tile.

Ron Cowell, lead archaeologist

The second phase of Roman activity left remains of a significant structure. Over thirty postholes were excavated, of which fourteen belonged to a large rectangular building that ran parallel with the northern enclosure ditch. This building measured around 1.5 metres by 4.5 metres. Pottery from the postholes of this building show that it was built in the second century AD. The internal layout of this large building was unclear, but numerous postholes within the area of the building suggest subdivision of the space into rooms. This was clearly a significant building. Construction on this scale would have required considerable amounts of building materials and effort. It seems the building was in use for some time. Two of the postholes stand out as probable repairs, differing from others in being packed with stone rather than clay. Pottery in the vicinity suggests the building was a house rather than an industrial building.

Two postholes were found 10 metres from the main group of structural postholes. These twin posts, from the same period of the house, may have supported a rack, perhaps for drying hay or for hanging carcasses for skinning and butchering.

Towards the end of the life of this farmstead the inhabitants were making roofing tiles. The stamps on some of the tiles show they were destined for the Roman army's fortress at Chester. Tile was found in some of the postholes of the later phases of the site, and waste was dumped in large quantities in the ditch when it was no longer needed. The presence of waste tile fragments indicates they were being manufactured near the site. Many tile fragments are marked with double or single arcs or wavy lines, signature marks of the tilemakers. Most significant of all, one had a Roman date, equivalent to AD 167.

Before we began to dig, we expected to find mesolithic flint. Soon we located a buried ditch and made a remarkable discovery – certainly one of the most fascinating finds of my career. It was a Roman roof tile, bearing a long stamp. The stamp gave a wealth of information – the name of the tile maker, the date probably AD 167, using the Roman dating system by the name of the consul in Rome, and the destination of the tile which was made for the 20th Legion in Chester.

Rob Philpott, archaeologist

One unique tile is stamped with the name Aulus Viducus, the contractor who was making roof tiles on behalf of the Roman legion. They would have been shipped to Chester where they were used to re-roof barracks for the 20th Legion. It is tempting to suggest that an iron stylus excavated from the site was used in managing the accounts of the tile-making industry. This elegant object with inlaid bands of brass is an unusual find for Merseyside. Another interesting find is a fragment of a quernstone made from basalt, which must have been imported from some distance away. This is an object type more commonly found on military sites in northern England.

The pottery and tile found at Ochre Brook indicate that the site was more 'Romanised' than other local and regional sites. The discovery of flat-headed iron nails of a type used

Tile stamped with the name of the maker, Aulus Viducus. (1997.78.431)

Illustration of a Roman stylus excavated at Ochre Brook, Tarbock. (1997.78.320)

for timber cladding suggests that Roman rather than local techniques of building were in use. Ochre Brook is the only known Roman pottery and tile production site in Merseyside.

Over a thousand years after the Roman site had fallen out of use a further phase of activity in the medieval period saw the local clay being dug out. This was probably to utilise the clay in building, such as for daub or clay floors. Dendrochronological analysis of timber found in these pits pinpoints this activity to the mid-fourteenth century AD.

This site was only found because field walking identified its mesolithic phase. Several other Romano-British farmsteads have been located when their distinctive ditched enclosures were identified during aerial survey. It's possible more farmsteads like this existed and await discovery.

FIND OUT MORE

📖 *Prehistoric, Romano-British and Medieval Settlement in Lowland North West England* by R. A. Philpott and R. W. Cowell

💻 Roman Merseyside activity book: https://images.liverpoolmuseums.org.uk/2021-10/Roman-Merseyside-2021.pdf

Medieval Merseyside

During the medieval period, Merseyside was a rural area with scattered villages and farms. The medieval period is often split into two parts: early medieval, the period after the Romans left (around AD 410) until the Norman invasion in AD 1066; and late medieval, the period from the Norman invasion in AD 1066 until the start of the Tudor period in AD 1485.

In Merseyside the evidence for the early medieval period is scant. In this time, waves of people arrived from Germany, Denmark, the Netherlands, Belgium and France: Angles, Saxons, Jutes, Frisians and Franks. The presence of pottery is one of the ways in which archaeological sites are identified and dated, but the early medieval period in Merseyside is largely ceramic-free. Vessels made from organic materials such as wood and leather have little or no trace. Place name evidence gives clues about the roots of many of our settlements, and the name 'Mersey' itself has roots in this era, meaning 'boundary river' in Old English. The Mersey formed the boundary between the kingdoms of Northumberland, Mercia and Gwynedd. From the ninth century, Norse (Norwegian) Viking people also started to settle in the Merseyside region, again leaving their mark in the many –by place names, meaning 'farmstead'.

After the Norman Conquest of 1066 we start to see changes in the objects, houses, and clothing people use. However, there is still not extensive evidence for this period in Merseyside. In the centre of Liverpool and other settlements it's likely that later buildings were constructed directly on top of earlier ones, following medieval street patterns. The digging of cellars will have stripped away the majority of the evidence for the earlier use of our town centre.

Dig 7: Hilary Breck, Wallasey, Wirral

Period(s) : Early medieval
Grid Reference : SJ 295 921
Lead Excavator(s) : Mark Adams, National Museums Liverpool
Year(s) Excavated : 2012
Accession Number : MOL.2011.11

Prior to construction of a new doctors' surgery, an excavation took place near the high ground in the historic settlement of Wallasey village. The area of land was named after the slope, from the Norse *brekka*. The site had the potential to contain evidence for the earliest phases of the establishment of the village.

Archaeologists hoe the site to reveal features. The Tudor and modern towers of St Hilary's Church are visible in the background

Wallasey Breck is next to St Hilary's Church. The present church was consecrated in 1859 and the tower of the former, Tudor, church still stands in the graveyard. At least three earlier, medieval, churches are known to have existed, and the earliest written evidence referred to a Norman church on or near the site. The dedication to St Hilary, the third-century bishop of Poitiers, France, is unusual, and may indicate an even earlier place of worship.

Medieval settlement in northern Wirral was dispersed and some of the modern centres, such as the nearby Liscard village, do not seem to relate to the earlier historic villages or hamlets. By the mid-nineteenth century Wallasey village was a ribbon development along the road of the same name.

> One interesting feature initially appeared to be a Victorian soakaway, but fortunately my colleague didn't just dig it out quickly and sectioned it properly. Soon I was standing on the edge of the trench saying, 'That looks exactly like some of the features at Irby'. We soon realised we had a Roman or medieval oven.
>
> Mark Adams, lead archaeologist

During the excavation, an unusual feature was revealed providing rare evidence for elusive early medieval occupants of the area. A large keyhole-shaped pit around 2 metres

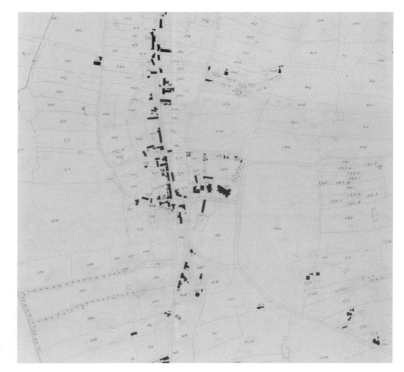

Tithe map
of Wallasey
village, 1842.
(Reproduced with
the permission of
Cheshire Archives
& Local Studies
and the owner/
depositor to
whom copyright is
reserved)

in diameter and 60 cm deep packed with sandstone blocks contained fragments of fired clay from an oven structure. This pit contained large quantities of charred cereal grain, mainly barley but with some oats and bread wheat. The base of the pit was scorched, indicating heating and burning within it. It is likely that this was used either as a corn drier or malting kiln, drying sprouted cereal grain for use in brewing. Samples of grain were recovered, which would have been dried in the kiln and stored for up to a year or two before use. The grain was radiocarbon dated to AD 390 to 580. Evidence for this immediate post-Roman period is unusual in the region, so a late fourth to late sixth century AD date for this site is exciting.

> I was given the task of excavating a scorched pit-like feature which turned out to be a possible oven/corn-drier, the earliest evidence for a post-Roman settlement dating to the late 4th – to late 6th century AD in the immediate area. If the original watching brief trench had been placed another metre or so to the east of the feature, it would have been completely missed and we'd have been none the wiser of such a significant feature!
>
> Clare Cunliffe, archaeologist

The kiln contained just fourteen objects, primarily pottery, some possibly early medieval, including one especially flat fragment that may represent part of the lid of the corn drier. The other significant find from the site was a possible saddle quern. This is another indication of everyday life and food production on the site. A saddle quern

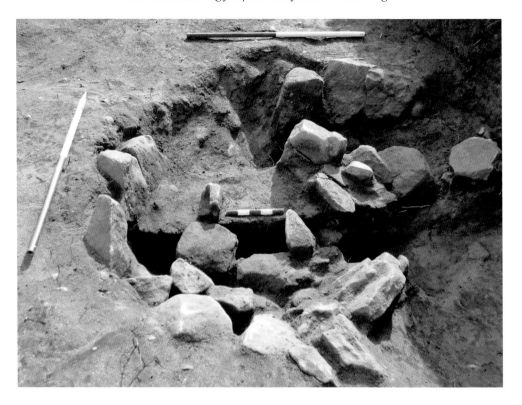

Above: Corn-drying kiln during excavation at Hilary Breck, Wallasey.

Left: Quern stone excavated at Hilary Breck, Wallasey. (MOL.2011.11.98)

was a common means of grinding wheat to make flour. This simple form of quern made from local sandstone is a type found from the prehistoric period onwards, and would have been commonly used for millennia.

> One of those rare archaeological sites where luck placed an evaluation trench over one of the most amazing features I have ever seen. The trench initially revealed what was thought to be a large circular pit into which a modern drain was laid. Later research showed that the rocks were probably the collapsed remains of an early medieval corn drier!
>
> Jeff Speakman, archaeologist

Other early medieval finds from the site are six small fragments of fired clay with the impressions of twigs, which are interpreted as daub, clay used in buildings.

The collapse of Roman control in Britain in the early fifth century AD appears to have had only limited impact upon Cheshire and the Wirral. It has been suggested that the structures of late Roman administration survived in the area until the seventh century AD, when the area was linked with the kingdom of Powys. It is possible that late Roman lifestyles continued into the fifth and sixth centuries at this site and others in Wirral.

FIND OUT MORE

'An Archaeological Watching Brief on Land at Hilary Breck, Wallasey, Wirral, Merseyside' by Mark Adams: www.archaeologydataservice.ac.uk/library/browse/issue.xhtml?recordId=1119330&recordType=GreyLitSeries

Dig 8: Mark Rake, Wirral

Period(s) : Early medieval
Grid Reference : SJ 349 823
Lead Excavator(s) : Mark Adams, National Museums Liverpool
Year(s) Excavated : 2016
Accession Number: MOL.2016.74

Before construction of new houses in Bromborough in 2016, an archaeological excavation took place. The site, in the middle of the village, is just to the north of St Barnabas' Church, which was mentioned in the Domesday survey of 1086. This location, in the heart of a settlement which existed by the eleventh century, provided potential to explore the early roots of a Wirral village. The site had been test-pitted in 2013–14 by members of the local community as part of the Discovering Bromborough project run by Big Heritage. Although small in size (1 metre x 1 metre) the test pits had found small pieces of Roman pottery and other finds, which further suggested that the site was worth excavating.

Another exciting and unusual indication of the site's potential was a large collection of Anglo-Saxon sculpture found in St Barnabas' churchyard during the nineteenth

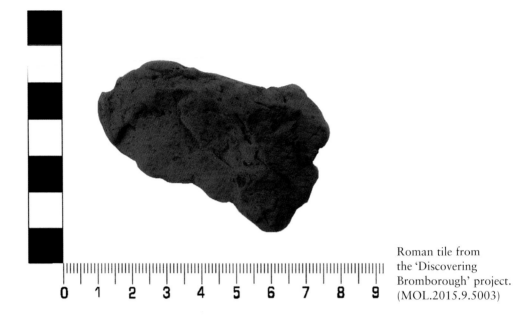

Roman tile from the 'Discovering Bromborough' project. (MOL.2015.9.5003)

century. The present St Barnabas' Church was built in 1862–64. When its late Georgian predecessor was demolished these sculpted stones were found to have been used in its 1828 construction.

The sculptures were early medieval in type, carved in local sandstone, and were the remains of crosses and grave markers. They show that there had been an early medieval church with a burial site as well as the place of worship. The roughly circular graveyard of the nineteenth-century church of St Barnabas may also be indicative of an early chapel. The sculptures had had a difficult past, being gathered following the demolition of the Georgian church in the 1860s, and placed in a tall pile in the rectory gardens. They remained there until 1909 when they were spread around the gardens in walls and rockeries. The rectory was demolished and rebuilt in 1933 and it was at this point that most of the carvings disappeared, despite a campaign by the Bromborough Society to save them. What actually happened is unclear: the builder at the time claimed not to have seen any carvings, though local rumour was that they'd been ground up to make sand for mortar.

The 2016 excavation aimed to find evidence for early settlement on the site and to see if any of the lost carvings might have survived after the 1930s. The first aim was achieved when ditches and pits were found at the southern end of the site. Small pieces of pottery within them demonstrated that they represented very early settlement in the area, dating to about 3,600–6,000 years ago, in the neolithic and bronze age periods. It seems that the ditches marked out a large enclosure or compound, possibly similar in size and shape to St Barnabas' churchyard, but its function is unknown. Identifying prehistoric origins to Bromborough was fascinating, but it is unlikely that the area was occupied continuously for the last 6,000 years. Like many other sites, it was probably occupied repeatedly on numerous separate occasions.

The archaeologists were on the lookout for evidence of Anglo-Saxon activity. None of the extant walls contained recognisable pieces of stone carved in the early medieval

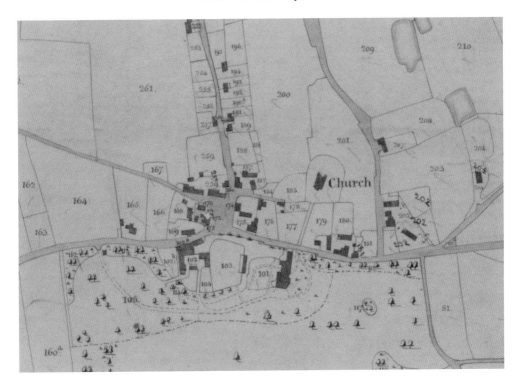

Above: Tithe map of the area around Mark Rake, Bromborough, 1840. (Reproduced with the permission of Cheshire Archives & Local Studies and the owner/depositor to whom copyright is reserved)

Right: Pile of sculpted stones arranged as a garden feature at Mark Rake, Bromborough. (© Trustees of the British Museum)

Fragment of bronze age pottery being excavated at Mark Rake, Bromborough. (MOL.2016.74.79)

period. Even when the northern wall was dismantled as part of the building project, and all the faces of the stones checked piece by piece, no carvings were found. The next stage of the search was to dig out the topsoil across the building site. The area covered was so big that this had to be done with a digger, but very carefully – no more than 5–10 cm deep at a time. Every piece of sandstone revealed by the digging was turned over and checked. Eventually one stone caught the eye of the digger driver, Ritchie.

> At first I wasn't sure what I was seeing, the stone's face was covered in wet soil, but a very careful brush with my fingers confirmed that shallow grooves in the stone's face were man-made and that we'd found at least one of the lost carvings.
>
> Mark Adams, lead archaeologist

The stone was a fragment of Anglo-Saxon sculpture, part of a slab carved between AD 900 and AD 1100. It is decorated with incised lines marking out a border around what is probably part of a cross. The area in which it was discovered was checked especially carefully, but only a thin layer of red sand and cobbles was found, suggesting that the local story about the builder in 1933 having smashed up the carvings was true and that there was just one survivor.

> I've found hundreds (possibly thousands) of interesting artefacts in the years I've worked in archaeology, but this one must make it into the top ten.
>
> Mark Adams, lead archaeologist

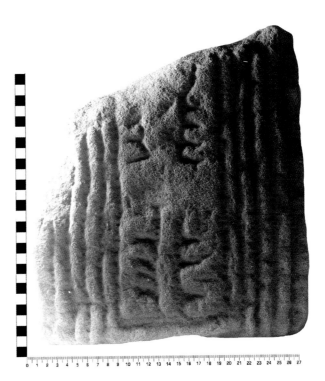

Fragment of an Anglo-Saxon sculpture rediscovered at Mark Rake, Bromborough. (MOL.2016.74.120)

Evidence for Anglo-Saxon life in this region is rare, chance finds and place names giving occasional glimpses. Sculptures which survive are often linked to Christian monuments, and it has been suggested that most sculpture was made at monasteries, which would have held religious and political influence at this time. The survival of carvings created to commemorate or as focus of prayer reflect the importance of faith in this period.

FIND OUT MORE

📖 *Corpus of Anglo-Saxon Stone Sculpture. Volume IX: Cheshire and Lancashire* by Richard Bailey

💻 Discovering Bromborough www.discoveringbromborough.wordpress.com

Dig 9: Roby Road, Roby, Knowsley

Period(s) : Medieval
Grid Reference : SJ 431 905
Lead Excavator(s) : Rob Philpott, National Museums Liverpool
Year(s) Excavated : 1990–91
Accession Number : 1996.13

A rescue excavation in 1990 focussed on an area of Roby Road near the heart of the medieval settlement, which had been granted a market charter in the fourteenth century.

The earliest surviving map of Roby, dated 1783, shows buildings along Roby Road, including in the area of the excavation. Roby Road had been widened in the post-medieval period to be a turnpike road. Alongside the road, buildings with outhouses, outdoor space, and orchards are shown. The limited amount of development and rebuilding through the intervening centuries made the survival of medieval archaeology a distinct possibility.

A handful of Roman pottery was discovered at Roby Road, demonstrating some early activity there, but the key phase of use of the site is in the medieval period when, in the thirteenth to fifteenth centuries, there were timber buildings. Excavated remains include long straight features, possibly beam slots for the base of walls of buildings or gullies for drainage; postholes; a series of large pits; and a surface made up of pebbles. Farming in the intervening centuries had damaged much of the archaeology, as the features were only shallowly cut into the boulder clay.

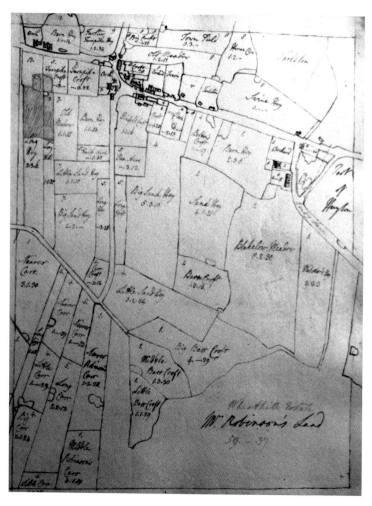

Map of Roby, 1783. (Courtesy of the Earl of Derby. Lancashire Archives: DDK/1770/18)

Gulley excavated at Roby Road, Roby.

The earliest building is represented by a shallow gulley that may have originally contained a horizontal beam. Stakeholes in the base of the gulley may represent protruding frames made of wattle, from which the walls were made. An interesting area nearby contained pebbles mixed with some fragments of medieval pottery. It's possible this is associated with a gulley, and may be a floor surface.

A row of deserted rectangular plots along the street marked the former site of houses and gardens. What was waste ground at first looked unprepossessing but once we began to open up a series of trenches, we soon began to find medieval pottery. A large pit, possibly for tanning, was the most productive, with dozens of broken fragments thrown into the pit as rubbish.

Rob Philpott, lead archaeologist

This gulley was cut through by one of three large pits, indicating that after the building was demolished activity on the site continued. The organic nature of the contents of the pit suggests they might have contained vegetable food, either as storage or waste. A fragment of an unglazed dripping pan was found in one of the pits, which dates their use to the 1400s. The pottery in these pits included handles, rims and bases of vessels, which survive more frequently than the thinner body of the pots. The final filling of the tops of these pits seems to date to the late medieval period, in the 1500s, marking the end of the use of the site.

The finds were small, fragmentary and often abraded; but as a group it is one of the largest assemblages of medieval pottery from an excavation in Merseyside – evidence of the ancient settlement.

Jeff Speakman, finds specialist

45

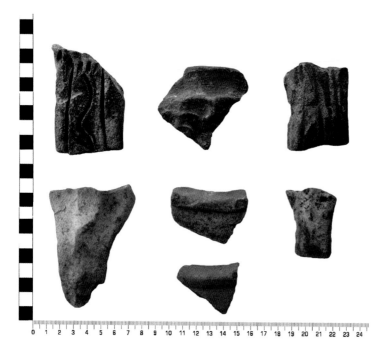

Medieval pottery excavated at Roby Road, Roby.

Excavation underway at Roby Road, Roby.

It is a pity that the floors and therefore the remains of activity and life in these structures weren't preserved, but the layout of the site gives us some clues. As is typical with medieval properties, there were buildings on the street frontage which possibly had a commercial function, taking advantage of the high street location. Behind this, industrial and domestic activity would have taken place in the yard, where the possible tanning pits suggest a trade in this area producing leather.

By the 1500s the population of Merseyside would have been just a few thousand, up to a thousand in Liverpool, with sizeable populations at West Derby, Roby and Prescot and others in smaller villages and hamlets. The Lord of Roby, Robert de Lathom, had a market charter there in the thirteenth century, and a stone cross, which still stands in Roby, may have been a market cross.

FIND OUT MORE

Medieval Roby:
www.roydenhistory.co.uk/mrlhp/articles/students/medievalroby/
medievalroby.htm

Dig 10: Castle Hill, Newton-le-Willows, St Helens

Period(s)	: Medieval
Grid Reference	: SJ 596 962
Lead Excavator(s)	: Revd E. Sibson / David Hollos
Year(s) Excavated	: 1843 / 1987–88
Accession Number	: 1987.70
Scheduled Monument Number	: 1009867

There have been two excavations to attempt to understand the distinctive mound in Newton-le-Willows known as 'Castle Hill'. In July 1843 Reverend E. Sibson excavated an area of the mound in the belief that it was the burial place of a Celtic king. Although there is a published account of the excavation, no original records or finds survive. The

Castle Hill,
Newton-le-Willows.

description of the excavation notes that burnt clay and charcoal were revealed. The excavators also thought they'd found a chamber 0.6 metres by 6.4 metres in plan and 60 cm high in the centre of the mound. Sibson thought that the soil bore the impression of 'an adult human body, its head to the west,' but any bone would have decayed, so interpretation of such marks is very difficult. A handful of objects were noted: a blackened rim fragment of wheel-thrown, unglazed, cream-coloured pottery, possibly from a Roman grinding bowl or *mortarium*, and a broken whetstone (sharpening stone). It is not known what happened to them.

> As the barrow at Castle Hill seems to be one of the most ancient, it is probable that some of the kings of the Celts, having been de-feated and slain, by the Belgae, were buried at Castle Hill, 2193 years ago.
>
> Revd Edmund Sibson, clergyman and antiquarian

By the 1980s it was believed that the site was the remains of a medieval motte-and-bailey castle, and a new excavation was planned to explore the origins of the mound, and to look at when it was constructed and how the site could have been used. Between April 1987 and February 1988 a Youth Training Scheme excavation explored the site. The aims were to investigate the base of the mound, to attempt to locate a ditch mentioned in written sources; and to dig trial trenches in the area to locate any other associated features.

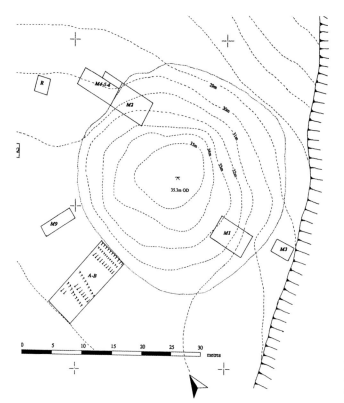

Plan of the trial trenches that were excavated at Castle Hill, Newton-le-Willows.

I was born in Newton-le-Willows and had long been fascinated by the local myths which encompassed Castle Hill … I remember feeling honoured and delighted to be part of the team to excavate our mysterious landmark. The report on the dig was rather inconclusive and it seemed to me that Castle Hill was holding onto its secrets for a little while longer.

Anne Christian, North West Archaeological Trust fieldwork assistant

This excavation proved the mound to be constructed of sand and turf, and identified its ditch on three sides. Timbers found within the mound probably represented a collapsed structure, maybe a small watchtower. The distinctive mound was therefore interpreted as a motte-and-bailey castle, built during the Norman period (the eleventh to twelfth centuries) with structures made from timber. It is possible that the medieval motte was constructed over an earlier, perhaps prehistoric, burial monument. Extensive disturbance to the site took place during the construction of the M6 motorway in the late 1950s when the field in which Castle Hill stands was stripped of topsoil and subsequently dumped upon with demolition and construction debris destroying any evidence of a potential bailey.

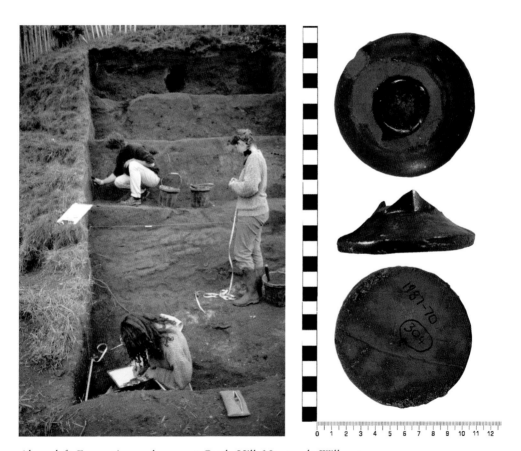

Above left: Excavation underway at Castle Hill, Newton-le-Willows.

Above right: Fragment of a faceted cup excavated at Castle Hill. (1987.70.50)

Why is it known as Castle Hill? ... Is it prehistoric or Roman? Did it act as a beacon dating from the 16th or 17th centuries? Or was it a windmill mound created at some unknown date? In 1987, with high hopes that advances in archaeological techniques would provide an answer, a three-month investigation of survey and excavation ... was undertaken ... To the archaeologists' dismay it was found that the field surrounding the mound had been entirely stripped of its topsoil, probably when the M6 had been built, leaving no archaeological evidence of any kind.

Jen Lewis, archaeologist

While the archaeology around the mound was disappointing, there were a few tantalising finds, such as a fragment of a post-medieval cup, made in a typically local faceted style in the seventeenth century.

The earliest surviving reference to a site known as Castle Hill in Newton appears in the estate survey papers of the Legh family in 1466, described as 'Castle Hill field', separated from the adjoining land by a diagonal 'ancient ditch'. If this site is a Norman construction, it is one of several motte-and-bailey castles in the region, each positioned at the heart of a medieval hundred (an administrative area).

While it is unclear whether Castle Hill is a Norman castle or a different type of construction, the excavation led to additional research into the medieval history of Newton-le-Willows. Newton is included in the Domesday Survey of 1086, recording that the administrative area of Newton hundred belonged to the king. Manors within the hundred were held by individuals. In 1190 the lands at Newton, which include Castle Hill, were granted to Robert Banastre by Henry II in exchange for the manor of Prestatyn in North Wales. By the mid-fourteenth century Robert de Langton was investing in a new manor house, probably near Newton Hall, and was granted a licence to crenellate in 1341. It is assumed that the Castle Hill site was abandoned by this time.

FIND OUT MORE

- Scheduling Description: www.historicengland.org.uk/listing/the-list/list-entry/1009867
- Transcribed leaflets from the two excavations: www.newton-le-willows.com/?p=2124
- *History of Newton in Makerfield* (Volume II) by John Henry Lane

Post-medieval Merseyside

The post-medieval period sees huge social and economic change. There is a significant amount of archaeological evidence for this period, with the early stages of industrial development leaving their mark on landscapes, in the finds and in the sites that are discovered.

Merseyside's links with the sea, always important throughout history, start to facilitate coastal and Irish trade. The pool of Liverpool, which had provided safe harbour in the medieval period, hosts more and more ships. This spurs the expansion of Liverpool into a bustling market town.

The religious upheaval of the split with Rome and Henry VIII's creation of the Church of England is seen in this region through recusancy – continuation of the Catholic faith recorded when people are punished. Some finds may subtly capture this religious agitation symbolically.

As Liverpool starts to grow and develop its mercantile links it becomes a fashionable town, and evidence for the dress, hairstyles and household goods that are desirable at this time paints a picture of the lifestyles of people in Merseyside.

Dig 11: South Castle Street, Liverpool

Period(s)	: Post-medieval
Grid Reference	: SJ 342 901
Lead Excavator(s)	: Peter Davey, Merseyside County Museums
Year(s) Excavated	: 1976–77
Accession Number	: 1977.88

When a new Crown Court was proposed for Liverpool, the newly formed Merseyside Archaeological Society and University of Liverpool Rescue Archaeology Unit stepped in to excavate the site of South Castle Street, which had been identified as of significant archaeological potential. The excavations in 1976 and 1977 focussed on two areas adjacent to the site of the medieval Liverpool Castle.

Working on this site with the excavator Peter Davey was an eye-opener. It was dug in 1976–67 at a time when historical, or post-medieval, archaeology was beginning to attract attention but remained outside the mainstream profession in this country. To dig a large site in the city centre of Liverpool was innovative thinking.

Rob Philpott, archaeologist

Liverpool Castle had been built between 1232 and 1237 on the site of the present Derby Square. The castle, with its defensive structure and its constable, demonstrated the lordly control of Liverpool by the earls of Lancaster. This was significant because Liverpool was an important port for military expeditions to Wales and Ireland through the period. It played an important role, regionally, in the Civil War, changing hands from Royalists to Parliamentarians, back to Royalists and then back to Parliamentarians again. In 1705 Queen Anne issued a warrant to survey and value the castle site with a view to granting a fifty-year lease to Liverpool Corporation for building purposes. Soon the corporation sought permission to demolish the castle and the last structures were dismantled in 1726.

The castle was in a defensible position next to the pool, a natural harbour that was one of the reasons why settlement began in Liverpool. From the later seventeenth century land around the pool was gradually reclaimed to create quays and in the early seventeenth century the 'Old Dock' was built within the area of the pool (see page **67**).

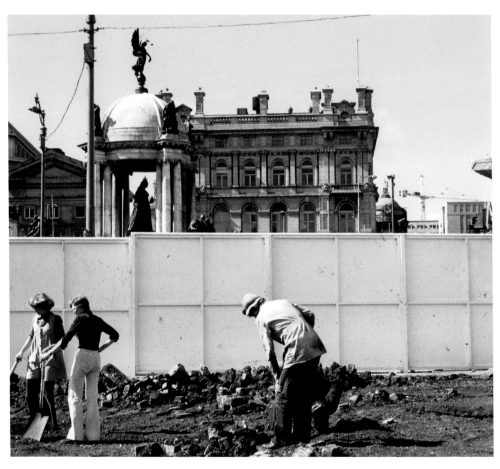

Excavation underway at South Castle Street, Liverpool. The Victoria Monument at Derby Square is visible in the background.

My memories of the first year of South Castle Street are of extreme heat for 6 weeks, then rain on the final day. I was zipping back and forth between Liverpool and Chester in my little green Renault to be at this fascinating dig. This was an important time for archaeology in Merseyside, the Archaeological Survey was being established and the first county archaeologist Brian Sheppard being appointed.

Peter Davey, lead archaeologist

The 1976 excavation revealed a range of features cut into the sandstone bedrock, which is very near the surface at this high point in the town centre. This included part of a seventeenth-century ditch system, possibly one of the earthworks constructed during one of the Civil War sieges, around 1644. Much of the evidence related to the early eighteenth-century market. The market stalls themselves were marked out as postholes, which would have supported structures to provide cover against the weather and tables for wares.

My first job in archaeology back in 1984 was working on the finds from South Castle Street, then one of the largest excavated waterfront sites in Liverpool. It was with a feeling of excitement that I would open the boxes of archaeological 'treasures' from my home town that I had never expected to see and was my introduction to the archaeology of Liverpool.

Jeff Speakman, finds specialist

Two large, distinctive features have been identified as the cage, a timber lockup described in historical documents, and a set of stocks. This unusual physical evidence of enforcement of law and order in this period starts to suggest a market full of characters. The Liverpool Town Books record the rules and regulations of the market, including what could be sold and by whom; for example, limiting the traders from outside Liverpool to selling goods only on market days: 'No person nor persons beyng forren [foreign] open nor shewe eny theyr wares but on the marcket daye.'

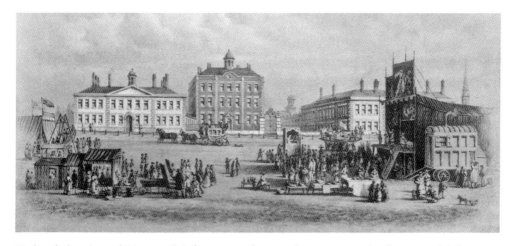

Undated drawing of Liverpool Infirmary with a market scene in the foreground. There are no known views of the South Castle Street market. (Courtesy of Liverpool Record Office, Liverpool Libraries)

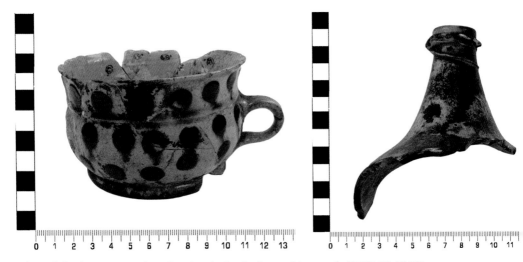

Above left: Slipware cup found at South Castle Street, Liverpool. (1977.88.3029)

Above right: Glass bottle found at South Castle Street, Liverpool. (1977.88.3064)

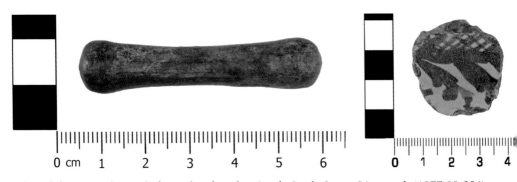

Above left: Wig curler made from clay, found at South Castle Street, Liverpool. (1977.88.556)

Above right: Gaming counter made from broken pottery. Found at South Castle Street, Liverpool. (1977.88.1527)

The finds paint a picture of a lively Stuart and early Georgian market: oyster shells discarded after the snacks were eaten; clay pipes smoked and broken and discarded, onion-shaped wine bottles, curlers from fashionable wigs, and a range of decorative pottery.

FIND OUT MORE

📖 *Excavations in South Castle Street, Liverpool 1976 and 1977* by Peter Davey and Robina McNeil

Dig 12: Church Road, Rainford, St Helens

Period(S) : Post-medieval – sixteenth to seventeenth century
Grid Reference : SD 481 003
Lead Excavator(S) : Sam Rowe, National Museums Liverpool
Year(S) Excavated : 2011–13
Accession Number : MOL.2011.82

The discovery, in the 1990s, of a distinctive seventeenth-century drinking vessel sparked local interest in a garden in Church Road, Rainford. When archaeologists at the Museum of Liverpool were alerted to Mr Meadows' find in 2011, the fascinating near-complete cup prompted them to start an excavation that would reveal an amazing array of locally made late sixteenth- and seventeenth-century pottery.

The site was transformed from a village garden to a hive of archaeological activity and became the focus of a community excavation, supported by the National Lottery Heritage Fund.

> The first 1 metre square trench opened produced the 'mother lode' of pottery. A dump of some near-complete late 16th century vessels, mostly cups. They had been dumped in an old boundary ditch at the back of the property, possibly as a result of the need for the potter to expand his premises beyond the old boundary and as a result he threw away the misfired, old-fashioned or broken vessels to help fill the ditch.
>
> Jeff Speakman, finds specialist

Mr Meadows' cup, the first find that gave a hint that the garden had archaeological potential. (MOL.2013.127)

Five trenches were excavated in the garden, revealing a field boundary ditch that had been re-cut several times. When the ditch was finally infilled potters working in the immediate vicinity dumped their misfired waste pottery and kiln waste. Of most interest are the wasters, pots that had misfired in the kiln and warped or glazes bubbled; saggars, large coarse pots in which finer vessels were fired; and kiln stilts and separators, small pieces of shaped clay or broken pottery used to help stack vessels.

> Excavating in the garden at Mr Meadows' surprised us all. I remember a colleague betting we would find loads of pottery, and we did! Within 20 minutes of opening the first test pit numerous shiny pieces of post-medieval pottery started to emerge. It was such a thrill to be the first people to see these drinking cups after they'd been buried in the ground for nearly 400 years!
>
> Sam Rowe, lead archaeologist

This site gives an insight into the work of potters in the area. Potting, in the late sixteenth and seventeenth centuries, was undertaken at several regional centres, which produced varied types of pottery for their local markets. The small village of Rainford in the post-medieval period was an active centre for potters.

Excavations also uncovered a clay floor, probably from a seventeenth-century pottery workshop, which lay above the main ditch deposits. Two flat stones at the edge of the compressed clay area may be padstones, used in the workshop building to support timber posts without allowing their ends to touch the earth – slowing the rate at which they'd start to decay and rot.

Looking at probate inventories produced after people died to record their possessions it's evident that many Rainford potters were also farming, with agricultural equipment

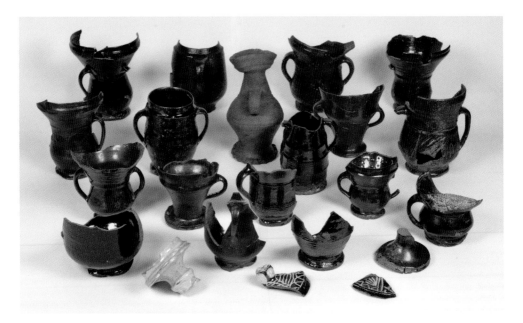

A range of forms of table vessels were discovered. Skilled potters made these very finely thrown pots.

and crops listed among their assets. These documents also demonstrate that potters were working in outhouses near their homes.

Exploration of this historic industry was undertaken by local people who volunteered to be involved with the project, undertaking research, digging and recording the site, and cleaning and cataloguing finds.

> I couldn't believe how very many exciting pieces we found and I was truly amazed at how the professionals were able so quickly to identify and date them. I also felt frustration when the tiny edge of a piece emerged but we weren't allowed to take a spade and dig it out there and then!
>
> <div align="right">Sharon Scott, Rainford's Roots volunteer</div>

Sharon Scott holding a lid she'd just discovered, which dates to *c.* 1600.

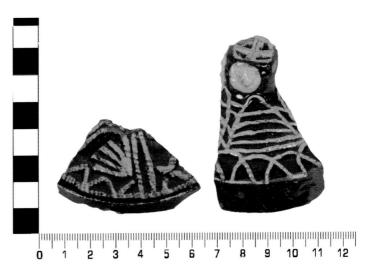

Post-medieval slipware lids found at Church Road, Rainford. (MOL.2011.82.1428 and MOL.2011.82.1434)

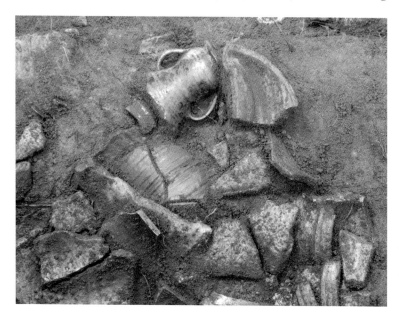

A dump of 'waster' pottery during excavation at Church Road, Rainford.

It was a privilege working with the local community in Rainford. We ran various community events, put on displays and gave talks and hosted an events day with ancient crafts and displays in the village hall. Everyone seemed to get a positive experience from the project, whether they actually helped dig the test pits or came to a talk or open day. It was great to see so many people want to get involved.

Sam Rowe, lead archaeologist

The highly skilled Rainford potters of the sixteenth and seventeenth century produced goods that were highly desirable. A distinctive local form is the faceted tyg, a tall drinking cup with an angular lower body created by vertical knife cuts. These have been found across North West England. Transported by travelling sellers, including 'basketwomen' who carried goods on their backs, Rainford pots made their mark across the region – in Lancashire and Cheshire, in Cumbria, the Isle of Man and Ireland.

Rainford is one of the most important regional and national sites where survival of the archaeology gives us a massive amount of evidence for early pottery production.

Jeff Speakman, finds specialist

FIND OUT MORE

- *The Pottery and Clay Tobacco Pipe Industries of Rainford, St Helens: New Research* edited by R. A. Philpott
- *Rainford's Roots: The Archaeology of a Village* by Sam Rowe and Liz Stewart

Dig 13: Lea Green, St Helens

Period(s) : Post-medieval
Grid Reference : SJ 511 923
Lead Excavator(s) : Andy Towle, National Museums Liverpool
Year(s) Excavated : 2002
Accession Number : LIV.2003.49

In 2002 the construction of a regional distribution centre by Somerfield provided an opportunity to excavate and survey a late medieval/post-medieval farm at Lea Green, near St Helens. Documentary research had already established that the farm was occupied during the late seventeenth century by Bryan Lea, 'yeoman of Sutton'. The archaeological excavation revealed sherds of pottery dating from the thirteenth century onwards, indicating that people may have been living around the site from the medieval period.

The excavation could trace the development of buildings on the site. The earliest house was probably from around the thirteenth century, but later walls cut right through this structure, so it was hard to decipher the layout. Some fascinating Elizabethan finds were revealed in a series of sixteenth-century pits. These were an amazing time capsule. Having remained waterlogged they preserved everything that had been thrown away into them, including horn, leather, animal hair, antler, seeds and wood fragments – types of find that often don't survive well.

A large stone-built, cellared farmhouse, barns and coach house were built in the seventeenth century. The foundations of these buildings were excavated, revealing a solidly built structure that clearly had longevity, having been in use for around 200 years. This wholesale seventeenth-century reorganisation of the site also included the digging of several ditches around the farm. One enclosure ditch contained clay pipes, which showed that it had been filled in by around 1720. The rubbish discarded in this ditch included a large number of household pots, including a decorative late seventeenth- /early eighteenth-century slipware cup, alongside more functional vessels

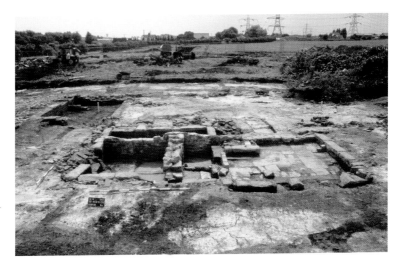

Remains of the seventeenth-century farmhouse at Lea Green, St Helens, during excavation.

Slipware cup excavated
at Lea Green, St Helens.
(LIV.2003.49.801)

for food preparation and storage. This, and other material in the ditch, could have been several generations old when they were thrown away.

> The excavations at Big Lea Green in 2002 remain one of my favourite digs ... They uncovered a sequence of pits, ditches and stone-built buildings and there was an outstanding assemblage of post-medieval pottery and tightly dated tobacco pipes.
>
> Andy Towle, lead archaeologist

The array of post-medieval pottery found at the site was of high quality and reflected a comfortable lifestyle at this farm. Much of the pottery would have been relatively locally made (see 'Church Road, Rainford', page 55) but some examples are imported from some distance, such as a cup made on the Surrey/Hampshire border.

> One of my highlights was excavating a very fragmentary 17th century border ware cup. Luckily recovered from a single point the many fragments were reconstructed to form a green glazed cup. The exterior of the body was coated by a decorative layer of tiny fragments of pottery under the green glaze. At first sight you would think this would make the cup extremely unpleasant to use but it is one of the most tactile and beautiful objects to hold. I always imagine hugging it with my hands whilst supping a hot drink or soup out of it.
>
> Jeff Speakman, archaeologist

The everyday life of the farmhouse was also evidenced in food-preparation pottery such as storage jars and pancheons. As well as near-complete vessels, some small artefacts tell us about life in the house. There were fragments of salting pans that were important for preserving meat such as ham. Their use is reinforced by a probate inventory for a

Fineware cups excavated at Lea Green, including the green border ware cup, left.

John Lea of Sutton, dating from 1 January 1623/4, which lists 'salt flesh' among his belongings when he died.

The eighteenth and early nineteenth centuries saw only relatively minor changes to the complex, with remodelling of one of the barns in brick and the digging of a number of drains. Household pottery continued to be thrown into garden soil behind the farmhouse. Between 1826 and 1849 a wide shallow ditch was excavated, defining the south-west corner of the farm. This ditch had the appearance of a medieval moat, but proved to be a nineteenth-century feature.

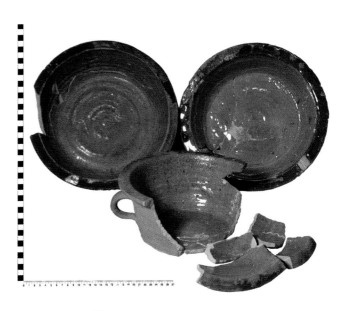

Pancheon found at
Lea Green, St Helens.
(LIV.2003.49.2059)

Bomb damage at Lea Green, St Helens, seen in damage to the cobbled surface, bottom right.

The farm was transformed between 1847 and 1891 with the reconstruction of the farmhouse in brick, the addition of a stable block to a barn, a new open-sided barn, the laying/relaying of cobbled yards and the reorganisation of an adjacent enclosure into a kitchen garden.

The farm underwent only minor changes during the early twentieth century, with alterations to the frontage of the farmhouse. The continuous habitation of the site was abruptly interrupted in September 1940, when the farmhouse was badly damaged by German bombing. The excavation revealed the impact of the bomb in a crater and ripples from shockwaves in the cobbled yard. The building was subsequently demolished and replaced by a brick-built farmhouse, which was in use until 2002.

One particular highlight was a dramatic interruption to occupation of the site: the farmhouse was badly damaged by German bombing during the Liverpool Blitz on 11th September 1940. Fortunately no one was killed but the shockwave was captured in the farm's cobbled yard – the blast having passed through the underlying clay remodelling the surface into a smooth dramatic curve.

Andy Towle, lead archaeologist

FIND OUT MORE

📖 *A Yeoman Farm in St Helens: Excavations at Big Lea Green Farm, Sutton* by Andy Towle and Jeff Speakman

💻 Museum of Liverpool online collection: www.liverpoolmuseums.org.uk/leagreen

Dig 14: Sefton Old Hall, Sefton

Period(s) : Medieval/post-medieval
Grid Reference : SD 356 011
Lead Excavator(s) : Frank Tyrer/J. F. Elton and R. H. Gambles
Year(s) Excavated : 1956–61
Accession Number : 1985.2

One of the first community excavations in Merseyside took place in the late 1950s to mid-1960s at Sefton Old Hall, a moated manor house. Initial investigations by Frank Tyrer were continued by the Merchant Taylors' School Archaeological Society led by J. F. Elton and R. H. Gambles. Unfortunately, only a small amount of the site archive of finds and paper records survives, making it challenging to understand the excavation and its discoveries.

The manor of Sefton is recorded in the Domesday Book and was long associated with the Molyneux family. While their primary residence from the sixteenth century onwards was at Croxteth Hall, they also held Sefton.

Sefton Old Hall was a significant structure on a platform surrounded by a moat. The moat and the buildings pointed to the status of the family: digging and maintaining a moat was a costly investment. The house was recorded as having thirty-three fireplaces in the Hearth Tax returns of 1666 – a large house to run.

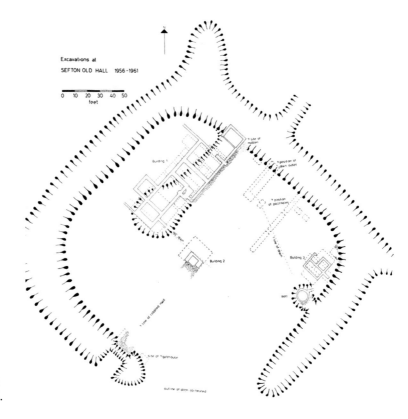

Plan of excavation
at Sefton Old Hall.

My interest in the moated site of Sefton Old Hall was fired when employed to analyse aerial photographs available for archaeological study. The excitement on recognising this well-defined earthwork led to further research about the history of the site and its occupation by the Molyneux family for over 500 years, until their removal to Croxteth Hall. But what I found was a sorry tale of fragmented 20th-century archaeological records coupled with poorly recorded artefacts.

Jen Lewis, archaeologist

Sefton Old Hall was significant enough to attract local visitors and in 1724 diarist Nicholas Blundell visited and described it: 'They [Thomas Brownbill and Mr Taping] went with me to Sephton; I showed them the seller [cellar] at the Hall and the Church.' The layout of the buildings changed over time: an estate map of 1769 shows buildings standing on the rectangular platform surrounded by a moat. The platform is divided across the centre by an access road which crosses the moat, with buildings on each side. One complex lies in the north corner, with a separate structure to the south-east, on the edge of the moat bank.

Remains were visible on the site in 1956, including the still-wet moat, two pontoons from a drawbridge and a well. In the opposite corner of Castle Field, the manorial fishponds could be identified. Like Castle Hill, Newton-le-Willows (see page 47), Sefton Old Hall was disturbed when the nearby road was rerouted through the centre of the site in 1964.

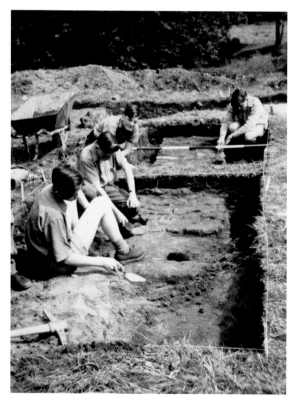

Excavation underway at Sefton Old Hall.

I was a fourth former and passed the site of Sefton Old Hall on the bus from Crosby to Aughton every day and decided it looked interesting. The dig was run by a history teacher, Mr Gamble, and took place on Wednesday afternoons. I studied archaeology again as a postgraduate. Thereafter followed a dozen books, countless excavations and surveys, the development of forensic archaeology and numerous projects.

<div align="right">Professor John Hunter, schoolchild-turned-archaeologist</div>

The moat was a major feature of the site, between 8 and 12 metres deep. It was served by feeder streams, which were also linked to the medieval fish ponds. This is one of over a hundred moated sites in Merseyside that indicate wealthier homes where the moat served as a status symbol as much as having any defensive role. The date of the initial creation of the Sefton Old Hall moat is not clear. The excavator thought that it had been re-dredged in the fourteenth century and its sides built up, sometimes behind a retaining wall of sandstone. However, the pottery from the bank was described as lead and salt glazed wares, which place this reworking of the moat in the seventeenth century. This, and many other post-medieval finds from the site, provide evidence of continued occupation throughout the hall's existence.

The layout of three phases of building at Sefton Old Hall were identified during the excavation. The initial construction, probably in the early seventeenth century, consisted of walls of sandstone blocks enclosing an area of 4.2 by 8.5 metres and a roughly constructed lean-to annexe. Following a collapse, a second phase was the rebuilding of the original structure along with an extension of the northern and southern walls in sandstone blocks. Further walls were built during a third phase probably built in the late seventeenth century. These final buildings included a brick wall enclosing two rooms built on poorly made rubble foundations. However, these building phases were predated by a much earlier building: fragments of an iron vessel uncovered in a turf layer above

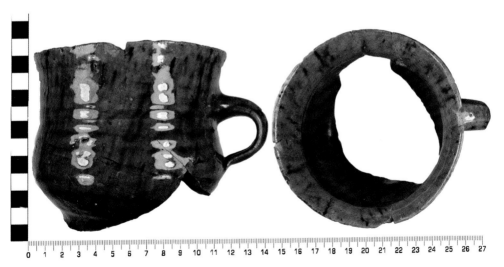

Mottled ware cup excavated at Sefton Old Hall. (1985.2.111)

Sgraffito dish excavated at Sefton Old Hall. (1985.2.105)

some fragmentary structural remains show that a building had stood on the site which had been destroyed by the fourteenth century.

The site conveys the wealth of the Molyneux family: the large buildings of the hall, the surrounding moat, and numerous showy objects give a sense of life here. Pottery sourced locally and from further afield was both functional and fashionable. An imported German Siegburg vessel decorated with fine detail and a bearded face would have been eye-catching. Another high-status object is a seventeenth-century, yellow sgraffito dish.

This house would have been a distinctive landmark and also significant to the local economy. Through excavation, documentary evidence and the finds, Sefton Old Hall provides us with a glimpse of affluent life in late medieval and post-medieval Merseyside.

FIND OUT MORE

📖 *Sefton Old Hall, Merseyside: excavations 1956–1961* by Jennifer Lewis

📖 *The Medieval Earthworks of the Hundred of West Derby* by Jennifer Lewis

Industrial Merseyside

During the 1700s and 1800s manufacturing industries were burgeoning in Merseyside and throughout Britain. Natural resources in Merseyside such as coal, sand for glassmaking and clay for potting helped local industries thrive, but it was the trading links via the port that spurred these industries most. Liverpool's first purpose-built dock opened in 1715, and links with industrial centres in other regional cities and towns developed with the advance of canal and rail networks.

The archaeological imprint of industrial growth is seen throughout the region, in standing buildings, communications like roads, canals and railways, adaptation of the landscape, and the wealth of finds which are the remnants of industrial activity. The physical remains of buried structures and standing buildings are embellished with rich documentary sources recording the activities within them.

Throughout this period it is impossible to disentangle any elements of Merseyside's history from its central role in the transatlantic trade in enslaved African people. This deplorable trade was the source of much of the wealth in Liverpool and Merseyside, contributing to new buildings and developments, which today are a part of Liverpool's historic environment. The repercussions of the trade in enslaved African people are still being felt across Britain and the world today.

The creation of new jobs in industries in urban centres encouraged people to move from the countryside into towns. During this period the population of Liverpool grew from a small Tudor town of around 1,000 people to a town of 82,000 people in 1801 to 711,000 by 1901.

Dig 15: Old Dock, Liverpool

Period(s) : Industrial
Grid Reference : SJ 343 899
Lead Excavator(s) : Vix Hughes, Andy Lane, Jamie Quartermaine and Caroline Raynor, Oxford Archaeology North
Year(s) Excavated : 2004–08
Accession Number : LIV.2001.23

The proposal in 1999 to create a new shopping centre in the heart of Liverpool provided an opportunity to explore one of the most fascinating and important sites in the city's history, its first dock, latterly known as the 'Old Dock'.

Every day was a joy of discovery... ropes from ships' rigging, pottery and glass bottles from the 18th and 19th century, a pouch of coins dropped overboard by a careless sailor and even a complete and perfectly preserved coconut!

Caroline Raynor, lead archaeologist

Opened in 1715, the Old Dock was a significant step in the transformation of a small settlement to a modern international port serving Liverpool's mercantile trade, including the town's growing involvement in the trade in enslaved African people. The construction of the Old Dock was a leap of faith. Liverpool had expanded in the previous fifty years, attracting new residents, including entrepreneurial merchants moving in to the town, especially from London, following the plague and the Great Fire. Liverpool Corporation risked bankrupting the town if their gamble to build an innovative dock hadn't paid off. The Old Dock took five years to construct and cost a massive £12,000. The average labourer would have earned about £20 a year at the time. The Old Dock was constructed following the infilling of the Pool, which had begun in the late seventeenth century. The mouth of the Pool itself was incorporated into the design for a commercial dock submitted by Thomas Steers, the dock engineer, whose design used the natural Pool. Construction was overseen by Richard Norris, a former mayor of Liverpool and a prominent slave trader.

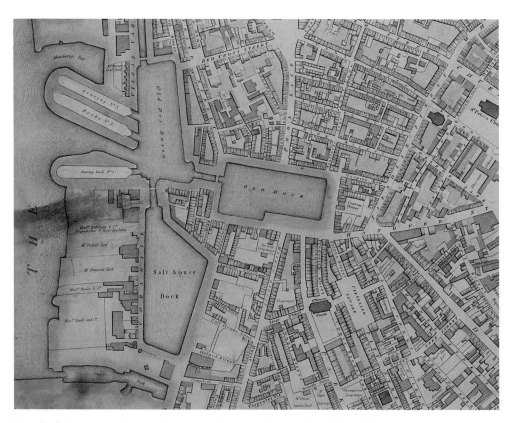

Detail of the Horwood Plan of Liverpool, 1803, showing the Old Dock.

I remember the excavations to the rear of the dock walls … descending deep through backfill material and the grey clays to identify a number of props and braces which had been put in place to bolster the brick dock during construction. These timbers were huge and in some cases were hewn from huge tree trunks with very little modification. Axe marks and saw marks … were still clearly visible thanks to the anaerobic conditions provided by the waterlogged clay. To me this was a great reminder of how the dock engineers would have used locally grown trees and other natural resources – a truly resourceful and low carbon approach to engineering.

Caroline Raynor, lead archaeologist

The dock was built directly onto the sandstone bedrock, which needed to be dug out in many areas, and the dock walls were constructed from brick. It had massive gates that were opened at high tide to give ships access, and so kept the level of water within the dock at the high tide waterline. Within the dock ships could unload straight on to the dockside while still afloat, enabling merchants to have their ships unloaded and reloaded within a day or two. The Old Dock was large, able to accommodate 100 ships within its 1.5 hectares.

Liverpool began to expand quickly through the eighteenth century, overtaking Bristol as the second-largest port in the country, after London. The trade in enslaved African people was central to this economic growth in Liverpool. Through the eighteenth century around 200 merchants controlled the slave trade in Liverpool, and a further 1,400 invested in them or were employed through them. A wider network of mercantile activity was built on slavery and the products of the work of enslaved people. By the

Walls of the Old Dock, Liverpool, during excavation.

1740s Liverpool controlled around 60 per cent of the British trade in enslaved Africans. Liverpool's economy was so intricately linked to slavery that in 1806 it was described as 'the metropolis of slavery'.

> I like to think of the Old Dock as a huge 300-year-old time capsule located directly under Liverpool One.
>
> Danny Wright, Old Dock tour guide

The construction of the dock created a new focus for life and businesses in Liverpool. The immediate area was home to warehouses, ships' chandlers, houses, pubs and counting houses. Some nearby buildings were excavated, and their cellars and finds paint a picture of dockside life. Pottery such as plates, cups, teapots, tea strainers, dishes and a jelly mould from homes in the area were found alongside inkwells, perhaps tied to the local business activity. Some of the objects demonstrate the international trading links, being items imported through the docks, some are British-made and imitating the style of imported goods.

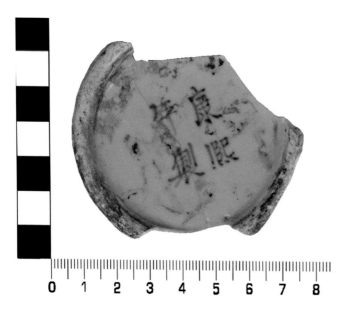

Chinese porcelain with maker's mark, dating to the late seventeenth/early eighteenth century. Found at Chavasse Park, Liverpool, adjacent to the Old Dock. (LIV.2001.23.301)

Marbles found at Chavasse Park, Liverpool, adjacent to the Old Dock. (LIV.2001.23. LIV.2001.23.2988)

There were a number of groups of seventeenth- and eighteenth-century pottery including what I like to call the Liver Duck plate. This near-complete eighteenth-century plate or shallow dish has a design scratched into its base. The image most closely equates to an emu with duck's feet, but made at a time when it is unlikely for the potter to have seen such an animal. Is it an image created from the description of one of the earliest sailors to visit Australia or is it a deformed local bird or even an attempt at a 'Liverbird'?

Jeff Speakman, finds specialist

The Old Dock was infilled in 1826 and a Custom House was built on its site. The Old Dock had become increasingly landlocked as docks, quaysides and facilities were constructed in areas of reclaimed land to the west. The Old Dock had been the spur to

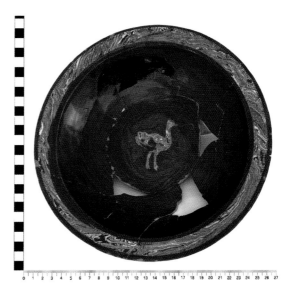

Agate ware plate with bird decoration, the 'Liver duck!' (LIV.2001.23.1674. LIV.2001.23.2048)

Pottery damaged during the Blitz in the Second World War. (LIV.2001.23.2865)

the development of the port of Liverpool, which culminated in 7 miles of dock system along the waterfront by the 1970s – from Seaforth in the north to Dingle in the south.

This site at the heart of the city remained in constant use with building and rebuilding of commercial buildings and homes. During the Second World War it received considerable damage, some of which is recorded on melted and charred pottery.

FIND OUT MORE

📖 *Archaeology at the Waterfront: Investigating Liverpool's Historic Docks* by Richard Gregory

☞ Take a tour of the Old Dock, from the Merseyside Maritime Museum: www. liverpoolmuseums.org.uk/whatson/merseyside-maritime-museum/event/old-dock-tour

Dig 16: Twist's House, Prescot, Knowsley

Period(s)	: Industrial
Grid Reference	: SJ 462 931
Lead Excavator(s)	: Peter Davey
Year(s) Excavated	: 1980
Accession Number	: MOL.2011.41

A fascinating group of locally produced pottery was discovered at Twist's House, Prescot, when a car inspection pit was being excavated at a property on Knowsley Park Lane. John and Simon Leigh discovered a large number of sherds of coarse red pottery under the cobbled floor of a former barn or outbuilding, sparking an investigation of the history of the site and its significance in the local pottery industry in the eighteenth century.

Twist's House gained that name around the 1960s to reflect the Twist family's occupation in the 1860s. On the Victorian tithe map it was known as 'Woodbine Cottage'. Joseph Twist was a 'Builder and Earthenware Manufacturer' in the 1861 census. The renaming of the house in honour of the Twist family is appropriate, as the site was discovered to have been related to the potting industry. Perhaps the naming was prophetic of the finds to come, or reflected historical research following occasional finds of pottery in the garden. It seems the Twist family moved from building into potting, and a decade later – by the time of the 1871 census – the cottage had passed to Joseph's son John, who was simply an 'Earthenware Manufacturer' along with his brother Charles. The family occupied several sites in Prescot, including the Mill Pottery at New Road (now Warrington Road) and in Kemble Street. The other sites are known from the early Ordnance Survey maps and historical records, but little is known of the Twist's House site.

This site would never have been recorded were it not for the enthusiasm of the members of the pottery class that I gave in the then recently opened Prescot Museum.

Historic map showing Woodbine Cottage, later known as Twist's House. (© Crown Copyright, courtesy of Knowsley Archive Service)

> They took responsibility for several different sites. The remains here were fascinating, the compacted sub-floor consisted of almost 100% pottery waste!
>
> Peter Davey, archaeologist and adult education class leader

While the site itself was not fully recorded by archaeologists, the information John and Simon Leigh provided was important in understanding the context of the finds. The sherds were packed in the ground in an area 90 cm x 74 cm at the southern end of the excavated area. They were within 70 cm of the surface. This was a dense dump of pottery, including items used for a range of household functions: storage vessels, cups, pancheons and pitchers/jugs.

While the link between the Twist family of potters and the discovery of pottery was tantalising, the pottery from this site is not the Twists' products, but dates to at least a century earlier than them. The darkware pottery of the late eighteenth century provides evidence of earlier pottery production in Prescot. There is a glimpse of historical evidence for this earlier pottery production on the site: a lease dated 1789 refers to a parcel of

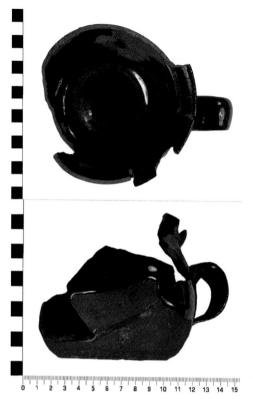

Cup excavated at Twist's House, Prescot. (MOL.2011.41.4)

land at or near Parkside in Knowsley containing two 'potworks' or 'mugworks'. The lease was drawn up between William Ward and Thomas Ashcroft and included the house of Thomas Spencer, Clay Potter. The tithe map (1848) describes a plot of land to the north of the cottage as Mughouse Field, which refers to a pottery site.

As well as the household pottery recovered at Twist's House, there are also finds of saggars. Saggars are the coarse pots used to protect finer vessels in the kiln, to ensure circulation of air and an even distribution of heat. Such finds are usually identified with pottery production sites rather than rubbish tips, as the saggars would not usually have travelled very far from the kiln, suggesting the site was on or near a pottery kiln.

Prescot was part of a network of pottery production centres in south-west Lancashire in the early industrial period. Through the eighteenth and nineteenth centuries locally produced pottery served towns across the region and was exported too – recent scientific analysis of finds in north America and the Caribbean is linking them to Prescot. The pottery made in Prescot and used in Merseyside was even sometimes tied to the developing role Liverpool was playing in the trade in enslaved African people: sugar moulds from Prescot were used in processing imported slave-produced sugar at Liverpool sugar houses (see 'Manchester Dock', page **79**).

A number of Prescot sites have started to reveal the story of the town's pottery-making. Unexpected chance finds often contribute to this, and we are grateful that the Leighs packed their finds into two suitcases and took them to Prescot Museum.

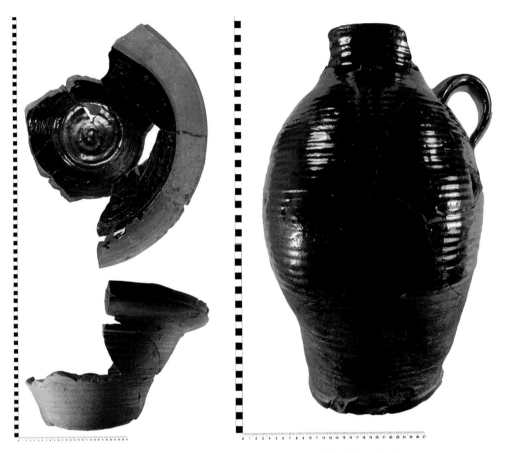

Above left: Pancheon excavated at Twist's House, Prescot. (MOL.2011.41.7)

Above right: Pitcher excavated at Twist's House, Prescot. (MOL.2011.41.9)

FIND OUT MORE

📖 *Pottery from Twist's House, Prescot by* C. Cresswell and P. J. Davey

Dig 17: Stanley Bank, St Helens

Period(s) : Industrial
Grid Reference : SJ 538 972
Lead Excavator(s) : Mark Adams, National Museums Liverpool
Year(s) Excavated : 2006–11
Accession Number : LIV.2004.42

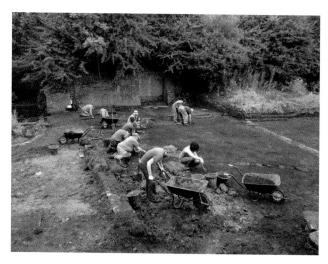

View of excavation underway at
Stanley Bank, St Helens.

Over several summers a community archaeology project explored the remains of a mill
site at Stanley Bank, St Helens. Excavation revealed two phases of activity on the site.
Initially, remains of the nineteenth-century, brick-built corn mill were explored. This
was a replacement for the late eighteenth-century, stone-built slitting mill, which was
also uncovered.

From the medieval period onwards wind and water power were harnessed to provide
driving power for many different types of mill, and Merseyside was dotted with them.
Slitting mills were water-powered mills with machinery that turned metal bars into rods,
which could then be manufactured into metal products.

Stanley Bank became a highly viable industrial site after the Blackbrook branch of
the Sankey Navigation opened around 1770, enabling easy transportation of products.
The Stanley Copper works were established by Thomas Patten in 1772. Thirty tons
of copper per week were cast into brass and copper ingots. These were then made
into rods, which in turn could be shaped into nails, bolts, plates and swages (dies for
hammering shapes into other objects). Another type of object produced at Stanley Bank
was manillas. In 1788 Stanley Bank had, ready for sale, 17 tonnes of manillas worth
£1,000. These horse-shoe-shaped objects were used as currency in the trade in enslaved
people in west Africa. No manillas were found at Stanley Bank as they would have been
valuable commodities taken away for sale.

An excavation at Stanley Bank in the 1980s had removed demolition debris to expose
extant walls and floors of the slitting mill and the wheel pit of a waterwheel.

The Stanley Bank slitting mill excavation was an excellent project! It started with a small
group of enthusiasts evaluating the site with targeted excavations and developed into a
large community project exposing the corn and slitting mill remains. It enabled people
from the local community to experience practical archaeology. The project answered
many longstanding questions about the mill site as well as providing enjoyment and
experiences to many people plus providing an additional amenity in the county park.

Roy Forshaw, Stanley Bank project veteran

Water mills were used extensively in the industrial period for processing foodstuffs, like grinding corn and oats; for powering machinery for wool and cotton manufacture; for powering sawmills, wood turning machines and mine machinery. At Stanley Bank there were two waterwheels providing power. The second, southern, wheelpit was discovered in 2008. It was built from large sandstone blocks and details of its construction included masons' marks of the people who worked on it. It was supplied by water from a culverted watercourse, covered by a brick arch. The movement of the wheel is even recorded in the archaeology as deep lines worn into the stonework.

The newly discovered waterwheel was covered by remains associated with the nineteenth-century corn mill, including a drain that sat within the infill of the wheelpit. This suggests that the previously discovered wheelpit excavated in the 1980s continued to be used when the second wheelpit was abandoned and filled in.

Excavation revealed that the change of use from iron slitting was not a simple conversion: the slitting mill had been demolished and the site levelled with clay before the corn mill was constructed.

Combining historical sources and archaeological evidence the history of the site can be reconstructed. The Stanley Iron Slitting Mill was established in 1773 by a partnership consisting of Alexander Chorley, Thomas Leech, John Postlethwaite and John Rigby to slit iron from the furnaces at Carr Mill to the north. The iron slitting mill does not appear to have been successful and in 1784 the mill was offered for sale. Rigby died in 1785 and in the same year Chorley was made manager of the works – now focussing on copper. Copper working seems to have ceased by 1813/14 and the site was in use as a corn mill by 1824. This structure was probably two to three storeys and used just the one wheel pit, which was probably altered at this time to try to improve efficiency. Around the mill would have stood storage buildings and houses for the mill workers.

As with all sites, the finds tell the story of activities pursued in this place. Many objects relate to manufacturing at Stanley Bank, such as metalworking waste and slag, discarded metal products and building materials. Other finds are the more personal remains of everyday workers' lives – people eating, drinking and smoking. The marking

Above left: Wheelpit with marks from a wheel, excavated at Stanley Bank, St Helens.

Above right: Wheelpit with masons' marks, excavated at Stanley Bank, St Helens.

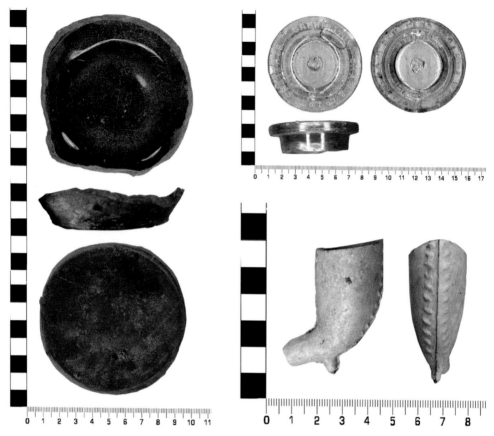

Above left: Base of eighteenth-century self-coloured ware vessel, excavated at Stanley Bank, St Helens. (LIV.2004.42.147)

Top right: Glass bottle stopper marked 'CANNINGTON SHAW', excavated at Stanley Bank, St Helens. (LIV.2004.42.25)

Above right: Tobacco pipe bowl excavated at Stanley Bank, St Helens. (LIV.2004.42.782)

on one bottle indicates it is from another important industrial site, Cannington Shaw No. 7 Bottle Shop in St Helens, which produced glass bottles from 1886 to 1918.

The whole Stanley Bank site is now a nature reserve, and the industrial archaeology is highly visible within the landscape.

FIND OUT MORE

☞ Visit Stanley Bank Nature Reserve, managed by the Woodland Trust

🖥 Stanley Mill website: www.stanleymill.org.uk

Dig 18: Manchester Dock, Liverpool

Period(s) : Industrial
Grid Reference : SJ 339 900
Lead Excavator(s) : Mark Adams, National Museums Liverpool
Year(s) Excavated : 2007
Accession Number : MLL.2007.14

In 2007 an archaeological investigation was undertaken at a key Liverpool waterfront site before the construction of the present Museum of Liverpool. The site is on land that was reclaimed as part of the late eighteenth- and nineteenth-century expansion of the docks, building the Manchester Dock and the Chester Basin out into an area formerly part of the River Mersey.

> One of the amazing coincidences of the excavation was the discovery of minutes from March 1807, describing the fitting of the lock, and our excavation of the finds almost exactly 200 years later in March 2007.
>
> Jeff Speakman, archaeologist

Before excavation a thorough search of documentary and map evidence had identified which areas of the docks would be revealed in the excavation. Manchester Dock was constructed as a tidal basin in 1785, and an entrance lock was added in the early 1800s – meaning that ships could spend longer in the dock afloat, even when the tide receded, to make loading and unloading more reliable and faster. The Chester Basin was constructed in 1795 and remained a tidal basin.

The excavation revealed the colossal sandstone-constructed dock walls and entrance lock, which had survived in a remarkably good state of preservation. Many of the associated dock fittings had also survived intact, including the timber dock gates, tidal gauge and sluice gate.

Detail from Gage's map of Liverpool, published in 1836, showing the central docks.

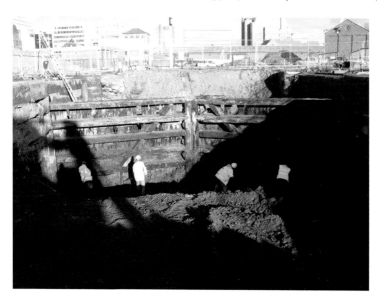

Manchester Dock, complete with dock gates, excavated in Liverpool.

The earliest archaeological remains were the walls and rubbish dumped on the site to reclaim land in the eighteenth century. A wall running north-west/south-east was discovered, roughly parallel with the modern riverfront wall, around 50 metres inland (east) of it. A length of about 8 metres was revealed, and its location suggests it was the wall which is shown first on the 1803 Horwood Plan of Liverpool. It didn't survive in full and it's possible it was never completed. It needed to be a solid structure to withstand the tides and weather at the waterfront, and was over 2 metres thick.

> As an extensive area of the car park was stripped, the upper surfaces of an intact dock wall structure emerged ... One of the best moments was as the machine excavated through the dock entrance in-fill, we realised that the actual dock gates and tidal gauge were still intact and very well preserved. One of the dock gates and the gauge are now actually displayed within the museum itself, almost exactly on the same spot where they were discovered!
>
> Clare Cunliffe, archaeologist

The quaysides around the Manchester Dock were created by infilling behind new waterfront and dock walls with a range of waste and rubbish from the town. This included sands and gravels dredged from the river and dumps of pottery made in Liverpool and Staffordshire. Within this mix was a large group of sugar moulds made in Prescot and brought to Liverpool to be used in the local industry of refining sugar imported from Caribbean and American plantations where it was grown by enslaved African people.

The waste dumps used to reclaim land also provided the first archaeological evidence for the manufacture of clay tobacco pipes in Liverpool. Clay tobacco pipes are an important type of archaeological evidence because over their 400-year history the form and shape of pipes changed repeatedly, making them easily datable, and useful in dating other finds discovered with them. Pipes were made in many locations. The Manchester

Sugar mould, marked
'ASHCROFT PRESCO[T]'
excavated at Manchester
Dock, Liverpool.
(MLL.2007.14.9)

Dock finds evidence production of pipes, including pipe clay in strips used to rest pipes while they air-dried.

> Discoveries included waste material and clay tobacco pipes from a number of local pipe makers. Many had the maker's name, one of which, Thomas Morgan incorporated the word 'Liverpool 1' 200 years before the shopping centre of the same name, the number probably referring to the company having more than one factory.
>
> Jeff Speakman, finds specialist

Other finds included small and easily lost objects: small personal items such as buttons, a few coins and tokens, and beads. The beads are highly significant as they are the type that would have been shipped from Liverpool to Africa to trade for enslaved people. Slave trader William Davenport & Co. became the supplier of half of all the glass beads that were exported from Liverpool to Africa in the later eighteenth century. These were mainly made in Venice and around Prague. This trade was huge. Between 1766 and 1770 the company sold £39,000 worth of beads, equating to almost £7,000,000 in today's money.

The Manchester Dock was one of many docks central to Liverpool's mercantile maritime development, and the technology for the operation of docks was developed

Bead excavated at
Manchester Dock, Liverpool.
(MLL.20057.14.3606)

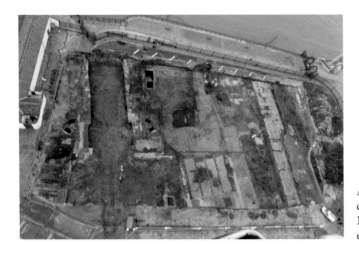

Aerial view shows the entrance lock of the Manchester Dock during excavation in 2007.

and refined in Liverpool. This was visible in the excavation where sunken recesses for hydraulic mechanisms driving the crane that was situated on the north quayside and four-lock gate mechanism chambers were revealed. Additionally, at least one sluice mechanism chamber was uncovered on the south quayside at the western edge of the trench. These features demonstrate the detailed design of docks in Liverpool by the later eighteenth century, and the ways in which water was managed.

As the docks continued to expand north and south the central docks increasingly became obsolete. Designed for smaller sailing ships they weren't easily accessible for the larger ships of the later nineteenth century. The Manchester Dock was infilled in the 1930s.

FIND OUT MORE

- *Archaeology at the Waterfront: Investigating Liverpool's Historic Docks* by Richard Gregory
- Museum of Liverpool online collection: www.liverpoolmuseums.org.uk/manchesterdock
- National Pipe Archive: www.pipearchive.co.uk

Dig 19: Oakes Street, Liverpool

Period(s) : Industrial
Grid Reference : SJ 356 907
Lead Excavator(s) : Liz Stewart, National Museums Liverpool
Year(s) Excavated : 2018
Accession Number : MOL.2018.53

As part of the 'Galkoff's and the Secret Life of Pembroke Place' project an excavation at the adjacent Oakes Street explored an example of courtyard or 'court' houses. Courts

were a form of housing built in Liverpool and other northern English towns and cities in the eighteenth and nineteenth centuries as a form of high-density, poor-quality housing for the growing urban population. The high employment at the ever-expanding Liverpool docks attracted people to the town, and through the nineteenth century Liverpool's population grew almost tenfold, reaching a peak of 846,101 in 1931.

Court housing was prevalent in Liverpool, but only one truncated example still stands: on Pembroke Place. This area of Liverpool was on the fringes of the town when the houses were built in the 1830s and was quickly subsumed into the suburbs. The court excavated was known as Missionary Buildings/Court 2 Oakes Street at different times. These houses were constructed in two phases: the west range by 1835 and the east range between 1835 and 1848, creating an enclosed courtyard. While this two-phase construction was not typical of courtyard housing, this first-ever excavation of an example of courts in Liverpool provided an opportunity to explore the material culture left behind by people living in courts in the late nineteenth and twentieth centuries.

The excavation at Oakes Street revealed an area of the cellars of 'Missionary Buildings' and the area of the courtyard. Uncovering the history of this court enabled exploration of the construction and alteration of the buildings, and evidence for life within housing that became notorious as 'slums'.

The buildings were found to be of relatively flimsy construction, with thin roughly built walls of uneven brick and degraded mortar. The walls of the light wells of the cellar windows were seemingly contemporary with, but not bonded to, the walls of the houses.

Evidence was also revealed for changes to the buildings. The cellar windows had been blocked up around 1900, at a time when there were campaigns to prevent people from living in the dark, damp cellars. In Liverpool more than anywhere else, these subterranean rooms were frequently sublet and provided the worst accommodation. The layout included no separate access to the cellars from outside at Missionary Buildings, but the rooms were clearly in use, evidenced by finds from within the spaces.

A wealth of finds shed new light on life in the courts. The areas of the excavation with most finds were the light wells. After the windows were blocked these voids became dumping grounds. An array of everyday items from around 1900 to 1914 like shoes,

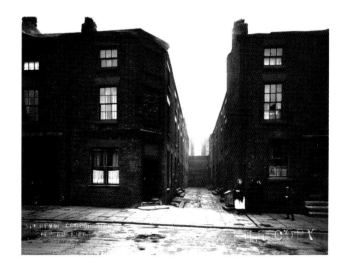

Photograph of Missionary Buildings, Oakes Street, shortly before demolition in the mid-1930s. (Courtesy of Liverpool Record Office, Liverpool Libraries)

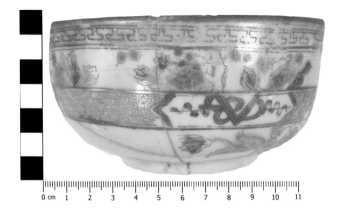

Porcelain bowl excavated at Oakes Street, Liverpool. (MOL.2018.53.93)

bottles and pots survived. Surprisingly, some of the objects found seem to be of higher status than might be associated with 'slum' housing, as courts had, by then, come to be known. Items like Chinese porcelain, fur clothing and perfume bottles demonstrate some high-quality items on the site, potentially owned by the people living in the courts. However, there were few ceramics sets. An exception is a cup and saucer with a matching pattern. This suggests that the owners potentially bought individual pieces as required when items broke or when they could afford them.

> This excavation revealed some unexpected things: the light well windows which had previously allowed a limited shaft of light from the enclosed court down into the dank cellars and basement rooms had been bricked up and became closed rubbish pits which filled up over a short period of time at the start of the 20th century. They were packed full of interesting objects!
>
> Jeff Speakman, archaeologist

Numerous bottles were recovered, but it has been found that all those embossed with labels about their contents are linked to companies making mineral waters, with none representing alcoholic drinks. This might be due to differentiation in returns policies for different types of drink. Perhaps a beer bottle attracted a refund, whereas a mineral bottle didn't. Maybe one of Liverpool's missionary organisations played a role in the buildings named 'Missionary Buildings' and may have required temperance in the homes. It may simply have been the choice of the occupants, the presence of stoppers for Kop's Ales, a non-alcoholic beer, suggesting a lifestyle choice.

Finds of toys demonstrate the presence and activity of children around the courts, playing out in the street and losing marbles, jacks, a domino and other toys, including down the light wells.

Life in cramped Liverpool courts would have been the everyday reality for thousands of people in the eighteenth and nineteenth centuries, but a hundred years later there is very little evidence to bear witness to their experiences. A thorough programme of 'slum clearance' in the late nineteenth and twentieth centuries housed people in far better accommodation and the courts were demolished. The Oakes Street courts were demolished in the 1930s and light industrial buildings constructed on the site. This excavation helped provide a more detailed picture of court life in Victorian and Edwardian Liverpool than had been possible before.

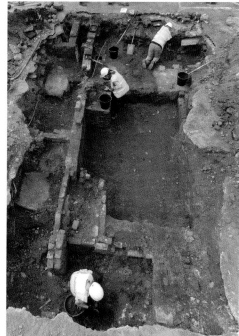

Above left: Mineral water bottle excavated at Oakes Street, Liverpool. (MOL.2018.53.21)

Above right: Excavation underway at Oakes Street, Liverpool.

Right: Kop's ale stopper excavated at Oakes Street, Liverpool. (MOL.2018.53.849)

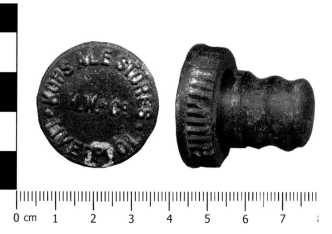

FIND OUT MORE

📖 Oakes Street Excavation – Museum of Liverpool online collection: www. liverpoolmuseums.org.uk/oakes-street-excavation

📖 *Courts and Alleys: A History of Liverpool Courtyard Housing* by Elizabeth J. Stewart

Dig 20: Hotties, St Helens

Period(S) : Industrial
Grid Reference : SJ 512 950
Lead Excavator(S) : Mick Krupa and Jamie Quartermaine, Oxford Archaeology North
Year(S) Excavated : 1991–97
Accession Number : 1998.28

Across Merseyside numerous large-scale industries developed from the post-medieval period onwards, often utilising local resources, as seen in pottery production at Rainford (see page 55). Around St Helens the presence of silica sand, coal and soda ash provided key raw materials for glassmaking. Ventures in glassmaking in the sixteenth and seventeenth centuries have been explored archaeologically at Bickerstaffe, where French Huguenot glassmakers who migrated to the area in the 1560s brought their skills to establish the industry. In St Helens, glassmaking developed to a new level in the nineteenth and twentieth centuries with extensive and innovative development of the industry.

The opportunity to explore the history of glassworks in St Helens presented itself in 1991 when the site of a Pilkington glass furnace was earmarked for redevelopment. Through investigation of standing remains, underground archaeology, historical sources and oral histories, the structure, functioning and working life of the glassworks were revealed.

Formally known as the Jubilee Glassworks, the site takes the name Hotties from the local nickname for the adjacent canal. The glassworks had been built on the side of the 1757 Sankey Canal, and discharged hot water into the canal, producing clouds of steam over the canal's surface.

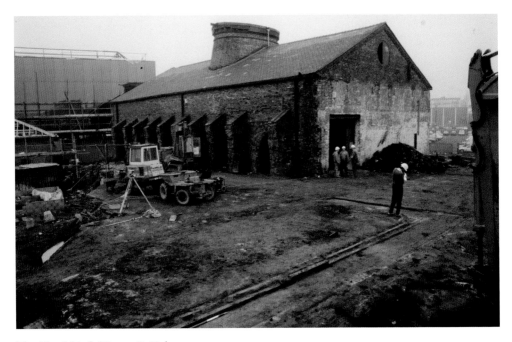

The No. 9 Tank House, St Helens.

The site represents St Helens' industrial development in microcosm, having seen coal mining, chemical works and then glass works in this place from the eighteenth to the twentieth centuries. The remains of Pilkington No. 9 Tank House reveal a glass furnace of an innovative design. This was a period of rapid development within the glass industry and Pilkington was at the forefront of that, frequently rebuilding and adapting designs. The tank house, now the centrepiece of the World of Glass Museum, is recognised as the most complete known glass furnace structure of its era.

I spent my school work experience transcribing oral histories about the 'Hotties' glassworks. It was the first thing which got me hooked on historical and industrial archaeology!

Liz Stewart, schoolchild turned archaeologist

The No. 9 Tank House was just one of fifteen furnaces in this glassworks built between the 1880s and the 1900s. It was built at the same time as a network of underground flues and vents that controlled the flow of gases to and from the furnace.

This site is very special as it is a rare example of an early regenerative flat glass furnace. As development at this time was so rapid it was cheaper to knock down and rebuild furnaces with new ideas after their relatively short lives. St Helens was one of the first places in the world to develop the Siemens process into a world-dominating technology.

David Bricknell, glass historian

The gas flue 'tunnels' at the Hotties site – now part of the World of Glass Museum. (Courtesy of The World of Glass, St Helens)

The structural remains represent the whole glassmaking process. At the melt end, outside the cone house area, the glass raw material batch is melted. This includes sand, excavated from nearby fields, many still visibly sunken, and broken glass cullet. The seven parallel gas supply flues in this area supplied gas to the regenerators, which received heat and transferred it back for tank furnaces.

The Tank House was the working end of the production system. The central feature of the Tank House is a huge cone, a massive 9.9 metres diameter, built on four huge cast-iron beams supported on four cast-iron columns. Below the cone are the excavated remains of the furnace. The furnace tank is removed, but the foundations are largely intact, with parallel walls representing the base of the furnace tank. Five access and ventilation tunnels served the regenerators in this area. To each side of the furnace are the remains of swing pits which were used in swinging and therefore stretching bubbles of glass into cynliders that could be cut open when partly cooled to create flat glass.

> I came to St Helens in 1960 when I married Antony Pilkington. He taught me how glass was made and how important sites such as the Hotties were, to glass making over many years. Now, as a trustee of the World of Glass Museum, I would encourage anyone intrigued by archaeology, to come to the museum and see the exciting finds from the past and learn about the inspiring plans for the future.
>
> Kirsty Pilkington

Protective equipment worn by glassmakers. (The World of Glass collection)

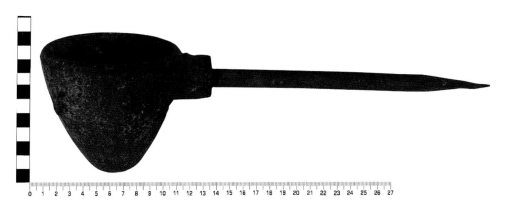

Ladle excavated at Hotties, St Helens. (1998.28.2)

Pilkington was committed to extensive research and development to improve its processes and the window glass produced. At the height of its success in the mid-twentieth century, Pilkington was one of the biggest producers of flat glass in the world, with a peak of 30,000 in the town working in the industry.

The finds from the site give a more personal viewpoint to the industrial process: large iron ladles used by the workers and fragments of their protective clothing survive. Glass working was hot, hard and dangerous. Dealing with molten glass was a highly skilled job.

This multidisciplinary project enabled the archaeologists to gather a wealth of historical, oral and archaeological evidence about the site. The tank house was built by Pilkington in 1887 for the manufacture of window glass using the blown cylinder method. The excavations revealed the fascinating structures of the continuous tank furnace. This site represents the rapidly changing and innovative design of glassworks in this era. Manager Windle Pilkington had visited Siemens Brothers' Dresden glass factory in 1872 and utilised ideas from there as well as adding his own innovations. Pilkington have continued that innovative approach, inventing the float glass process in 1957 and developing Activ self-cleaning glass in 2001.

FIND OUT MORE

☞ Visit the World of Glass Museum, St Helens: www.worldofglass.com

📖 *'The Hotties': Excavation and Building Survey at Pilkington's No. 9 Tank House, St Helens, Merseyside* by M. Krupa and W. Heawood

📖 *Float: Pilkington's Glass Revolution* by David Bricknell

Conclusions

These twenty sites from across Merseyside help us to understand how people interacted with and altered the landscape in which they lived. From prehistory to the industrial period and beyond people have used the spaces around them, to support their basic needs of food, warmth and safety, developing trade and industry while creating homes and communities.

Over 150 archaeological investigations have taken place in Merseyside, and this book explores just a handful from the collections of the Museum of Liverpool. Investigation of these sites provided information about the past and the site archives within the regional archaeology collection at the Museum of Liverpool continue to do so. Archaeology is not just about digging. The capturing of archaeological information by recording a site with photography, context sheets, measured drawings and levels, alongside more recent techniques such as geophysics, photogrammetry and LIDAR is only part of the process. It is through post-excavation work, analysis and interpretation that the stories of the past can be uncovered, and, most importantly, shared.

Many of the excavations chosen to represent the story of Merseyside took place as a condition of development. The protection of archaeological sites through the Planning process, and the opportunity to explore them is enhancing our knowledge of Merseyside's history. Equally, much of what we know about the region's past has been investigated in community excavations, and many groups are exploring Merseyside's past and sharing their discoveries to enhance the picture. Bringing together people with different experiences and knowledge can enrich the understanding of our shared heritage.

Archaeology, the study of human activity in the past, can also be seen in our built environment and through single finds, which have been uncovered through field walking, gardening and metal detecting. By recording these chance discoveries with the Portable Antiquities Scheme we can ensure that even single finds contribute to our archaeological knowledge. Gathering knowledge of our shared past helps us gain a sense of the longevity of human activity and a sense of place. The actions of people in Merseyside through history have shaped the landscape and settlements we know today. The archaeological digs explored in this book help illustrate the impacts of people in the past on Merseyside. The twenty sites explored here represent the chronology of Merseyside's past, and the way we understand that in the twenty-first century.

Glossary

Agate ware	Type of post-medieval pottery. Made from a combination of various coloured clays to create a decorative effect.
Aerial photographs	Photographs taken from the air to give an overview of a site and identify crop marks (see below) or raised or sunken features.
Artefact	An object made by a human being.
Berewick	A village or hamlet within a manor.
Black burnished ware	Type of Romano-British pottery. Dark grey or black pottery that has been polished (burnished).
Border ware	Type of post-medieval pottery. Made from white or red clays border wares are often green-glazed and sometimes called 'Tudor green'. Made on the Hampshire/Surrey border.
Burgess	A citizen of a borough with full municipal rights.
Chert	A hard sedimentary rock similar to flint, which originates from limestone areas.
Consul	A consul held the highest elected political office in the Roman Republic presiding over the Senate and commanding the army.
Context	Layer or situation in which a find or feature is discovered.
Costrel	A portable flask for carrying drinks, with ears or loops for a strap to be attached.
Crop marks	Patterns visible in the crops due to differences in growth because of buried walls, ditches or other archaeological deposits.
Darkware	Type of post-medieval pottery with dark brown glaze. Both 'fineware' vessels for use on the table and 'coarseware' cooking and food preparation vessels are made from darkware.
Domestic	In the home.
Excavation	A 'dig' – removing earth from the ground in a systematic way while recording archaeological remains in order to study the past.
Extant	Still present on a site – surviving.
Feature	A physical change or structure in the ground which has been made or altered by human activity.

Fieldwalking	Systematically crossing an area of land on foot to identify archaeological features or artefacts by eye.
Flint	A hard sedimentary rock used to make stone tools through a process of chipping, known as 'knapping'.
Hundred	An administrative area within a shire.
Industrial	Associated with manufacturing activity and connected work such as raw material extraction or transport. Sites and objects used in the period of the Industrial Revolution (around AD 1750–1900).
In Situ	In its original location.
Microlith	A small, narrow point, probably used as an arrowhead or projectile point.
Mortarium	Type of Roman pottery. Bowl-shaped with rim adapted for gripping, a spout and grit embedded in the inner surface. Primarily used for mixing food.
Mottled ware	Type of post-medieval pottery. Glazed with yellow to dark brown glaze with dark brown/black mottles/streaks.
Pancheon	A wide and shallow earthenware vessel used in food preparation, especially standing milk to allow cream to separate, and making cheese.
Posthole	A cavity in the ground that would have held a wooden upright, usually to support a structure.
Radiocarbon dating	A technique used to obtain a date for organic material such as wood, charcoal, bone, or pollen.
Salt glazed ware	Type of post-medieval and industrial period pottery. The glaze contains salt and forms a textured (orange peel) surface. Usually hard-fired 'stonewares'.
Self-coloured ware	Type of post-medieval pottery. The glaze is clear and the vessel takes its colour from the colour of the clay.
Sgraffito	A technique for decorating pottery in which a design is created by scratching through a surface layer of thin clay 'slip' to reveal a contrasting level beneath.
Slipware	A type of pottery decorated with 'slip', a diluted clay solution used on ceramics for decoration.
Slitting Mill	A watermill that flattens rods of metal then cuts them into sections for further manufacture.
Spindle Whorl	A perforated weight used with a wooden drop spindle to twist, or spin fibres into yarn, for later making into textiles.
Stylus	A pointed implement used for writing from the Roman period onwards.
Survey	The process of collecting data – there are many archaeological survey techniques such as landscape survey or geophysical survey.
Turnpike	Roads on which a toll is charged.

Bibliography

Bailey, R.N., *Corpus of Anglo-Saxon Stone Sculpture. Volume IX: Cheshire and Lancashire*. (Oxford University Press: Oxford, 2010)

Barker, T. C. and J.R. Harris, *A Merseyside town in the Industrial Revolution: St Helens 1750 –1900* (Liverpool University Press: Liverpool, 1954)

Belchem, J. (ed.), *Liverpool 800: Culture, Character and History* (Liverpool University Press: Liverpool, 2007)

Cowell, R.W., 'The Prehistory of Merseyside' in *Journal of the Merseyside Archaeological Society*, Volume 7 (1991), pp. 21–60

Cowell, R.W. and J. Innes, *North West Wetlands Survey: The Wetlands of Merseyside* (Lancaster Imprints, 1994)

Cresswell, C. and P.J. Davey, 'Pottery from Twist's House, Prescot (Site 28)' in *Journal of the Merseyside Archaeological* Society, Volume 5 (1989), pp. 97–102

Davey, P. and R. McNeil, 'Excavations in South Castle Street, Liverpool 1976 and 1977' in *Journal of the Merseyside Archaeological Society*, Volume 4 (1984), pp. 1–158

Eckwall, E., *The Place-names of Lancashire* (University of Manchester: Manchester, 1922)

Edwards, B.J.N., *Sefton Old Hall* (unpublished report, 1965)

Gregory, R., C. Raynor, M. Adams, R. Philpott, C. Howard-Davis, N. Johnson, V. Hughes and D.A. Higgins, *Archaeology at the Waterfront: Investigating Liverpool's Historic Docks* (Lancaster Imprints, 23, Oxford Archaeology North: Lancaster, 2014)

Hollos, D.B., 'Castle Hill, Newton-le-Willows' in *North West Archaeological Trust* (unpublished notes, 1988)

Krupa, M. and W. Heawood, *'The Hotties': Excavation and Building Survey at Pilkingtons' No 9 Tank House, St Helens, Merseyside* (Oxford Archaeology Series: Lancaster Imprints, Volume 10, 2002)

Lewis, J.M., 'Sefton Old Hall, Merseyside: Excavations 1956–1961' in *Journal of the Merseyside Archaeological Society*, Volume 2 (1978), pp. 53–72

Lewis, J., 'The Medieval Earthworks of the Hundred of West Derby: Tenurial Evidence and Physical Structure', British Archaeological Reports, British Series 310 (2000)

Lewis, J. and R.W. Cowell, 'The Archaeology of a Changing Landscape: The Last Thousand Years in Merseyside' in *Journal of the Merseyside Archaeological Society*, Volume 11 (2002)

Longworth, C., 'Flint and Chert Availability in Mesolithic Wirral' in *Journal of the Merseyside Archaeological Society*, Volume 10 (2000), pp. 1–22

Philpott, R.A., 'Medieval Towns of Merseyside' in *Journal of the Merseyside Archaeological Society*, Volume 7 (1991), pp. 105–20

Philpott, R.A. and M. Adams, *Irby, Wirral: Excavations on a Late Prehistoric, Romano-British and Medieval Site, 1987–96* (National Museums Liverpool: Liverpool, 2011)

Philpott, R.A. and R.W. Cowell, *Prehistoric, Romano-British and Medieval Settlement in Lowland North West England* (National Museums Liverpool: Liverpool, 2013)

Philpott, R.A. (ed.), *The Pottery and Clay Tobacco Pipe Industries of Rainford, St Helens: New Research* (Merseyside Archaeological Society: Liverpool, 2015)

Power, M. (ed.), *Liverpool Town Books: 1649–1671* (Record Society of Lancashire and Cheshire: 1999)

Rowe, S. and L. Stewart, *Rainford's Roots: The Archaeology of a Village* (Merseyside Archaeological Society: Liverpool, 2014)

Sheppard, B., 'Aerial Photography Aiding Landscape Studies on Merseyside' in *Journal of the Merseyside Archaeological Society*, Volume 2 (1978), pp. 83–84

Sibson, E., 'An Account of the Opening of an Ancient Barrow Called Castle Hill near Newton-le-Willows in the County of Lancaster' in *Manchester Literary and Philopsophical Society Memoirs*, 2nd Series 7 (1846), pp. 325–47

Stewart, E. J., *Courts and Alleys: A History of Liverpool Courtyard Housing* (Liverpool University Press: Liverpool, 2019)

Tibbles, A., *Liverpool and the Slave Trade* (Liverpool University Press: Liverpool, 2018)

Towle, A.C., and J.I. Speakman, 'A Yeoman Farm in St Helens: Excavations at Big Lea Green Farm, Sutton, 2002' in *Journal of the Merseyside Archaeological Society*, Volume 14 (2012)

Acknowledgments

Hundreds of archaeologists have explored our region's past since the late nineteenth century, and we are indebted to their work and the records they've left behind of their excavations. The lead excavators named in this work have been at the forefront of this work, and have been supported by armies of professional and non-professional archaeologists undertaking fieldwork and post excavation analysis of finds and site records. This publication would not have been possible without all their painstaking research and records.

Thanks to all the archaeologists who have taken a trip down memory lane to talk to us about excavations. Thank you to Rob Philpott, Ron Cowell and David Bricknell for their comments on the text, and Jon Murden for his contributions to the introduction. Thank you to Heather Beeton, Jess Hornby and Natalie Sutcliffe for their work producing beautiful images of the objects from the Museum of Liverpool collection. Thank you to colleagues for discussing the content of this book with us throughout. Thank you to James Worth for proof-reading (all mistakes the authors'). Thank you to the support we have received from Amberley Publishing.

The excavations featured in this book have been supported in a variety of ways: lottery players have supported work at Lunt, Rainford, Stanley Bank and Oakes Street through the National Lottery Heritage Fund. Investigation of some sites was community led, such as Twist's House, Castle Hill and Sefton Old Hall. Many sites were excavated in advance of development and the developers supported the excavations. This range of opportunities has enhanced understanding of Merseyside's past over decades of archaeological work.

About the Authors

Liz Stewart is the Lead Curator of Archaeology and the Historic Environment at the Museum of Liverpool. She is an archaeologist with a research background in buildings archaeology, who has undertaken fieldwork and research on sites covering many periods. Liz curates the regional archaeology collection, using objects to explore the stories of the region's past. She is author of *Courts and Alleys: A History of Liverpool Courtyard Housing*.

Vanessa Oakden is the Curator of Regional and Community Archaeology at the Museum of Liverpool with a background in fieldwork, small finds and community archaeology. Vanessa curates the regional archaeology collection and develops community archaeology projects. She is the author of *50 Finds from Cheshire* and *50 Finds from Manchester and Merseyside*.

Liz and Vanessa are part of the team who curate the Museum of Liverpool's regional archaeology collection: over 100,000 objects from Merseyside from the mesolithic to modern periods. The museum's archaeology team engage people in the archaeology of the region, run community archaeology projects, create displays and exhibitions, and manage the development of the collection.